MW00630062

IMAGES
of America

BERKLEY, FREETOWN, AND LAKEVILLE

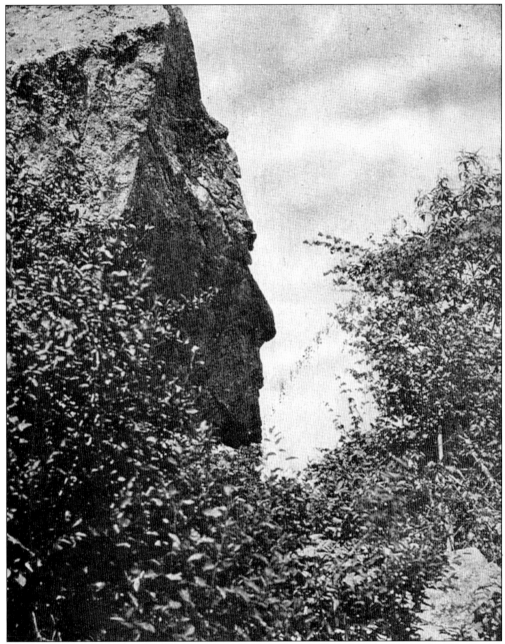

Joshua's Mountain is a natural rock formation, 40–50 feet high, that looks like a Native American. It is found on Freetown's original town lot No. 23. It was named for Joshua, the son of John Tisdale, the first owner of the lot. Joshua's Mountain is located on Slab Bridge Road. (Courtesy Bob Dorsey, Winter Hill Antiques.)

On the cover: Please see page 21. (Courtesy Berkley Historical Society.)

IMAGES
of America

BERKLEY, FREETOWN, AND LAKEVILLE

Gail E. Terry

ARCADIA
PUBLISHING

Copyright © 2007 by Gail E. Terry
ISBN 978-0-7385-5036-7

Published by Arcadia Publishing
Charleston SC, Chicago IL, Portsmouth NH, San Francisco CA

Printed in the United States of America

Library of Congress Catalog Card Number: 2007922285

For all general information contact Arcadia Publishing at:
Telephone 843-853-2070
Fax 843-853-0044
E-mail sales@arcadiapublishing.com
For customer service and orders:
Toll-Free 1-888-313-2665

Visit us on the Internet at www.arcadiapublishing.com

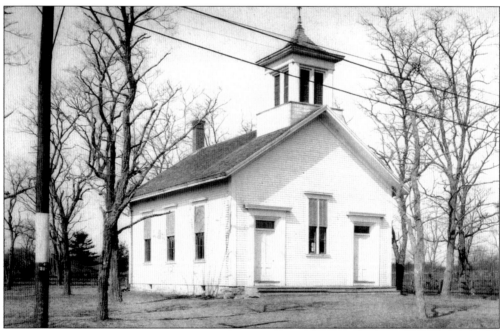

Grove Chapel was built in 1875, on Bedford Street. The bell from the Bell School was placed in the cupola in 1927. When the building was no longer being used as a church it was sold. Today it is the museum of the Lakeville Historical Society. (Courtesy Lakeville Historical Society.)

CONTENTS

ACKNOWLEDGMENTS

I wish to thank everyone who has assisted in the completion of this book. This includes not only the people I name here but also all those who have contributed photographs and other items to the local historical societies. Their generosity has made this book possible. I wish to thank the three historical societies for allowing me to use their photographs and for their knowledgeable assistance. In appreciation, I have arranged for all author's proceeds from this book to be given to them. Thank you to all individuals who allowed me to use their photographs and postcards. I have credited their contributions following the picture captions.

Thank you to my husband, Leonard Terry; my father, Merle J. E. Stetson; my sister, June A. Paduch; and my brother, Douglas Stetson, for their assistance and support. I want to especially thank Patricia A. Stetson for her drawing of the *Assawampsett* steamboat.

Thank you to each of the following for their help in completing this book: Betsy Dean, Jean E. Dean, Arlene Di Cola Medeiros, Carol Andrews Mills, June F. Conant Moskal, and Jeanne Russo of the Berkley Historical Society; president Lynwood H. French, Norine Davis, Melanie Dodenhoff, Bob Dorsey, and Miriam Gurney of the Freetown Historical Society; and president Brian Reynolds, Hubert L. Atwood, Lois Atwood, Annette Perkins Delano, Nancy Johnson La Fave, and Elizabeth A. Williams of the Lakeville Historical Society. I also wish to thank my editor at Arcadia Publishing, Erin Stone.

INTRODUCTION

It is difficult, perhaps impossible, to convey one's sentiments about a place. What we can do is talk about the people, places, and events associated with a town. We can also look at photographs, paintings, and drawings of a town and its citizens. Hopefully by viewing the images of a time gone by provided in this book, we can have a better understanding of what life was like in the time our ancestors lived here and what life was like when we were younger. For those who have lived in or visited one of these towns, hopefully these photographs will revive your own feelings and attachments to the town, be it pride, love, nostalgia, or something even deeper.

Although the pictures in this book cover the time period from the late 1800s until about 1965, some of the history of these towns from their earliest times is conveyed within the captions. It is not surprising to those who are familiar with these towns that it seems as if little has changed during this time except for an ever-increasing number of people living here.

Berkley was incorporated in 1735. The town was named for Bishop George Berkeley. A clerical error in Boston left out the middle *e* in the town's name. All the land in Berkley was originally a part of Taunton, with a portion of the town also having at one time been a part of Dighton, which had already broken away from Taunton. Berkley's land area grew through five transactions with the last area, Myricks, being annexed in 1879. The town encompasses 17.36 square miles, and it is one of the smallest towns in Bristol County. Berkley began as a farming town, and later it was also known for many years for its shipbuilding industry, which began in 1790. In 1866, the largest two-masted schooner in the world was built in Berkley. The railroad junction in Myricks made that section of town a hub of activity for freight and travel as well as entertainment. The Bristol County Central Agricultural Society Fair, Railroad Grove Hall, and Myricks Church clambakes were popular locations that drew crowds to Myricks from throughout New England.

Freetown began with Ye Freeman's Purchase, which was transacted in 1659, when a four-mile tract of land was purchased from Chief Wamsutta and his squaw, Tattapanum. This land was divided among 26 freemen who are considered the original purchasers. Each of the 26 lots had frontage on the Assonet River. Freetown was incorporated as a town in 1683. Changes to the land area of Freetown occurred when a portion of Tiverton was annexed in 1747 and when Fall River was set off in 1803. The town had a shipbuilding and shipping commerce community named Assonet on the Assonet River. Assonet is named for the Native American word meaning "song of praise." A blast furnace in East Freetown led to the development of a separate community in that part of town. Freetown had some rivers that were ideal for waterpower use, and several mills and factories lined their banks. Freetown was the fifth town organized in Bristol County, and it covers 38.30 square miles.

Lakeville was incorporated in 1853, having previously been a part of the town of Middleborough. The majority of votes for naming the town were for the name Nelson. Nelson was chosen to honor Job Peirce Nelson, Esq. Nelson declined the honor, and he urged the town to be named Lakeville. Lakeville had an iron industry with ore being dredged out of the many lakes and ponds in town. In the late 1700s, the industry was taking more than 500 tons of ore per year to East Freetown to be smelt. Growing cranberries became a natural farming activity because the boggy land of a town with so many bodies of water was ideal for that crop. In the late 1800s, the town became a recreation area, with summer communities lining the shores of the lakes and ponds and taverns and inns lining the highways. Lakeville is located in Plymouth County and covers 36.14 square miles.

This book provides just a glimpse of the historical background of these towns through this collection of photographs. For a more detailed account of the towns' histories you can refer to local histories including the following books: *History of the Town of Berkley, Mass.* by Rev. Enoch Sanford, *Myricks Massachusetts: A Farming Settlement A Railroad Village* by Gail E. Terry, *History of the Town of Freetown, Massachusetts* by Palo Alto Pierce, *History of the Town of Lakeville Massachusetts* by Gladys Vigers, and *The Beechwoods Confederacy 1709–1809* by Kenneth C. Leonard Jr.

One

BERKLEY

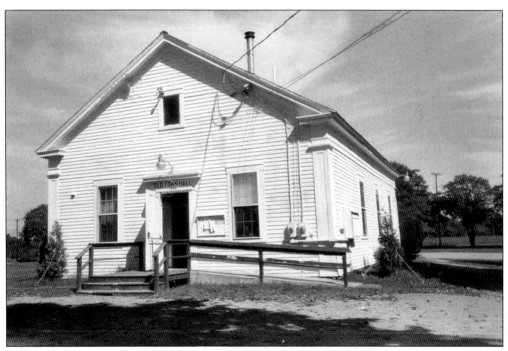

Berkley Old Town Hall is located on Berkley Common. The November 12, 1849, town meeting minutes state that the town hall had been constructed. Before that time, the town meetinghouse was used as a church and as the town meetinghouse. Berkley Old Town Hall was used for town meetings until 1989. Today the building is owned and preserved by the Berkley Lions Club. (Author's collection.)

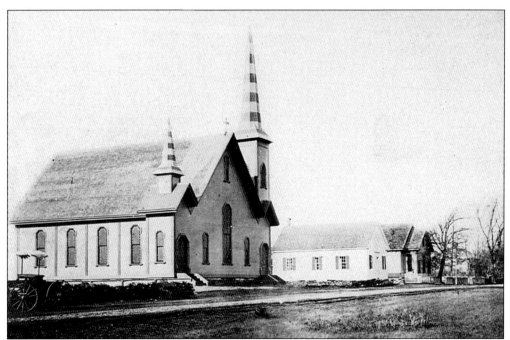

A second church was organized in Berkley in 1848. A chapel was built about where the grammar school was later built. In 1875, the First Methodist Episcopal Church built its church, which is pictured here about that time. In 1881, it purchased a used Hook organ, and it is the second-oldest Hook organ still in existence. (Author's collection.)

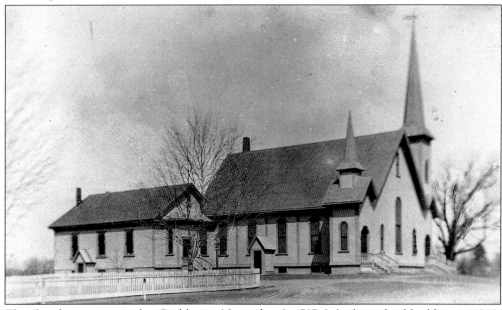

The church was organized in Berkley on November 2, 1737. It built its third building in 1848, on the site of the original town meetinghouse. This building burned in 1903. It purchased the church and chapel from the nearby Methodist church. The buildings were moved to the original meetinghouse lot, and the two congregations merged. It is now the Berkley Congregational Church. (Author's collection.)

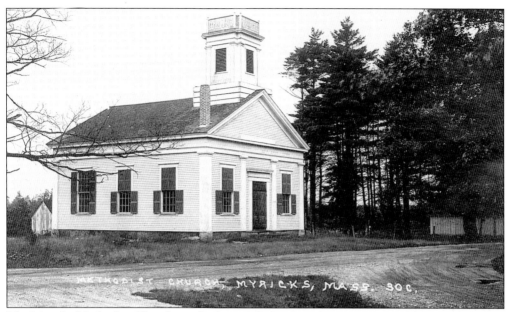

The Myricks Methodist Church was built in 1853. Despite numerous name changes, the church has been ministering to the community continuously from that time. The church hall, Grove Hall, was used for clambakes that served over 1,000 from 1882 to 1929. A new Grove Hall, attached to the back of the church, was built in 1950–1951. (Author's collection.)

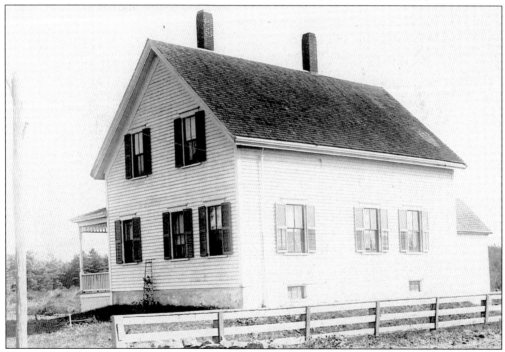

The Myricks Methodist Church parsonage was built about 1895, after the Myricks Methodist Church received a bequest of $500 from Hephzibah Davis Taylor. In 1978, when the house was no longer needed as a parsonage, it was sold to Elwell H. Perry Jr. A plaque has been placed on the house by Perry to denote its historic past. (Author's collection.)

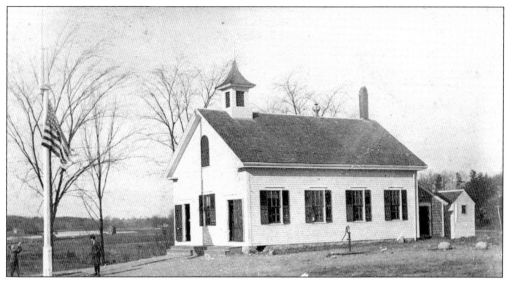

At one time there were seven schools in the town. Pictured here is the Berkley Bridge School, which was designated as school No. 3. It was built in 1872, at the corner of Elm Street and Berkley Street. Other schools included Assonet Neck School, No. 4, on Bay View Avenue, and Skunk Hill School, No. 6, on Padelford Street. (Courtesy Berkley Historical Society.)

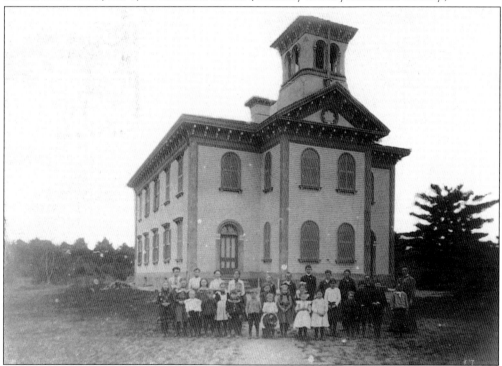

Built in 1853–1854, the Mirickville Academy was one of the last such academies to be built in Massachusetts. Students from throughout New England attended school here. The academy closed in 1866. It was then purchased by the City of Taunton, which used it as a grade school. The building burned on October 25, 1904, when a fire destroyed many buildings near the railroad. (Courtesy Merle J. E. Stetson.)

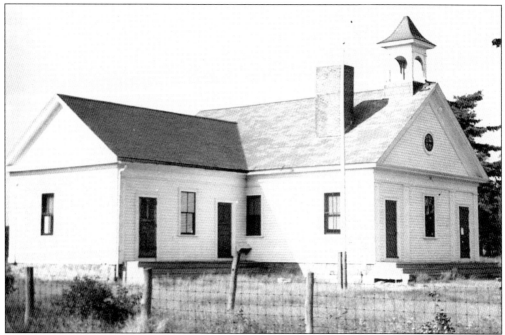

The Myricks School, No. 7, was built as a one-room schoolhouse in 1905. The addition was built in 1910. This school was the last of the community schools to close. Students from the Myricks School were sent to the Berkley Grammar School in 1944. This building is now owned by the Berkley American Legion, Post 121. The post is named for Scup Rose. (Courtesy Merle J. E. Stetson.)

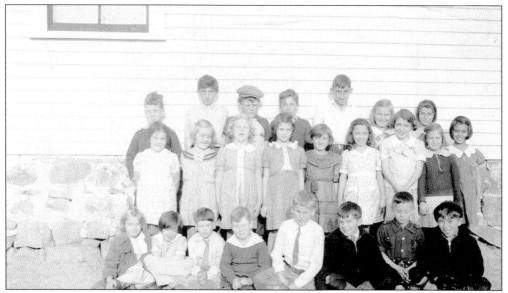

Myricks School students are pictured here about 1932. The teachers at this time were Millicent B. Hackett and Mildred Ashley. Hackett taught at the school in Myricks from 1927 until it closed in 1944. Ashley taught there from 1926 to 1937. There was an active Parent-Teacher Association at this school that provided such things as building improvements, games, food, and clothing for the children. (Courtesy Berkley Historical Society.)

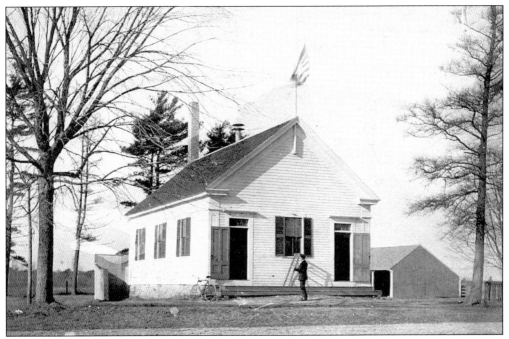

The Common School was school No. 1. It was located about where the grammar school was built in 1926. There were two entrances to the school, and boys would enter through one door and girls through the other. In the 1850s, there were two sessions of school, one in the summer and one in the winter with students usually of ages 5 to 15. (Courtesy Berkley Historical Society.)

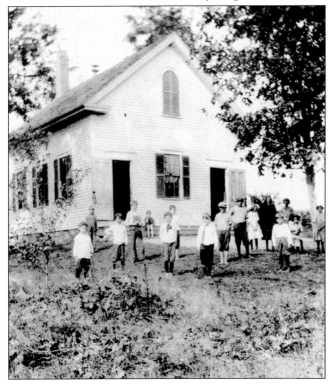

Algerine School, No. 5, was located at the intersection of Algerine and Bryant Streets. Children who lived nearby attended the school until the Berkley Grammar School opened in 1926. The building was sold to Maria Hakajarvi, who had the school torn down. The lumber was used to build an addition to her house on Anthony Street. (Courtesy Eilene L. Atkins.)

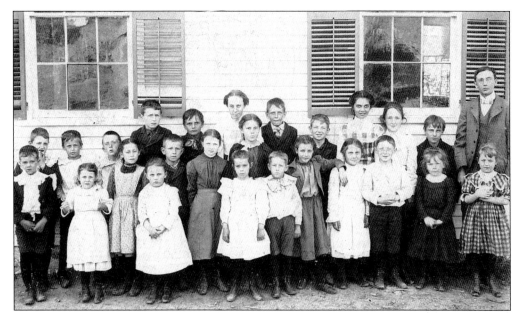

Berkley students in 1900 are, from left to right, (first row) Herbert Babbitt, Mary Rothermel, Elizabeth Rothermel, Doris Chase, Norman Whitaker, Katy Flyn, Helen Alexander, Willie Rothermel, Nora Williams, Rebecca Hathaway, John Rothermel, Ruth Howland, and May Myers; (second row) Howard Myers, Murry Chase, Henry Hathaway, Merle Whitaker, Ralph Hoxie, Lilly Gidmark, Annie Rothermel, Clifford Hathaway, John Flyn, Della Babbitt, Jessie Howland, George Williams, and principal Herbert Sargent. (Courtesy Berkley Historical Society.)

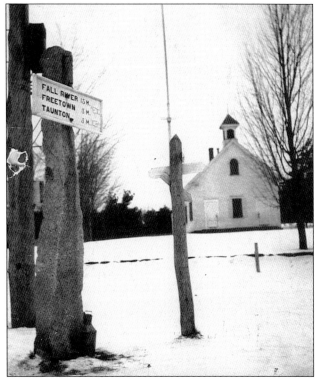

Burt's Corner School was school No. 2. It was located at the intersection of Berkley Street and North Main Street. The Burt's Corner School section of town was annexed to Berkley from Taunton in 1810. This view was taken in February 1918. Today the schoolhouse is a residence. (Courtesy Berkley Historical Society.)

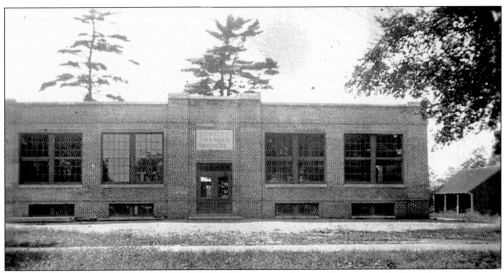

The four-room Berkley Grammar School opened in 1926. At that time all the other schools in town were closed except for the school in Myricks. In 1937, two additional rooms were added to the school. When the Berkley Elementary School opened in 1962, this building became the Berkley Junior High School. In 1989, the building became the town office building. (Courtesy Berkley Historical Society.)

Berkley Grammar School students from the eighth grade class of 1956–1957 are pictured here. They are, from left to right, (front row) Richard Rose, Tony Martin, and Edward Goodwin; (second row) Linda Lorenz, Nancy Bindon, Carolyn Dow, Nancy Clark, Sara Martisus, Thelma Sylvester, and Carol Andrews; (third row) Lynn Allan, Linda Silvan, Linda Goff, principal Oscar Lameroux, Eleanor Fournier, Mary Fernandes, and Gerald Guertin; (fourth row) Anthony Rose, Beverly Ashley, Susan Fernandes, Dixie Flint, and Phyllis Barboza. (Courtesy Berkley Historical Society.)

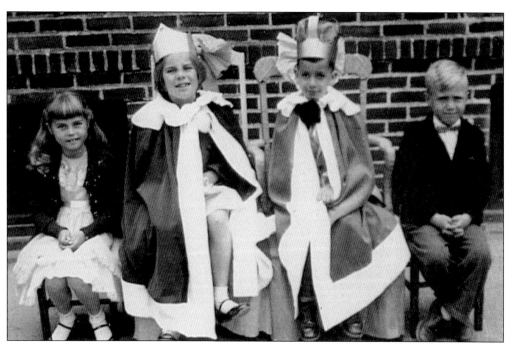

May Day 1956 was celebrated at the Berkley Grammar School with a king and queen and their attendants, as had been done for several years. The king is Arthur Luiz, and the queen is June Stetson. The attendants are Karen Viveiros and John McCrohan. May Day activities also included a maypole dance with the girls' dresses matching the color of the ribbons on the pole. (Courtesy Merle J. E. Stetson.)

The eighth-grade girls shown on May Day 1957 are, from left to right, (first row) Linda Silvan, Sara Martisus, Mary Fernandes, and Eleanor Fournier; (second row) Carolyn Melesky (page), Carolyn Dow, Lynn Allan, Thelma Sylvester, and Charlene Zietler (page); (third row) Dixie Flint, Linda Lorenz, Susan Fernandes (queen), Carol Andrews, and Phyllis Barboza. (Courtesy Berkley Historical Society.)

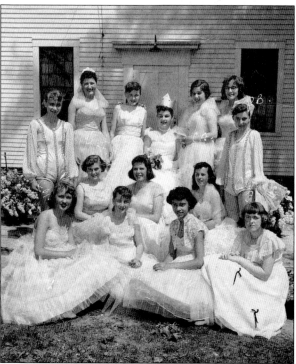

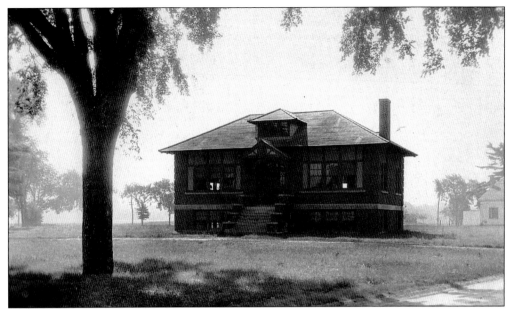

The Berkley Public Library was built with $5,000 from the Carnegie Foundation, and the library received $25 from the state to purchase books. It opened on Berkley Common on December 12, 1919. The basement was finished years later, and it has been used by the town clerk, town committees, and as a meeting hall for clubs. (Courtesy Berkley Historical Society.)

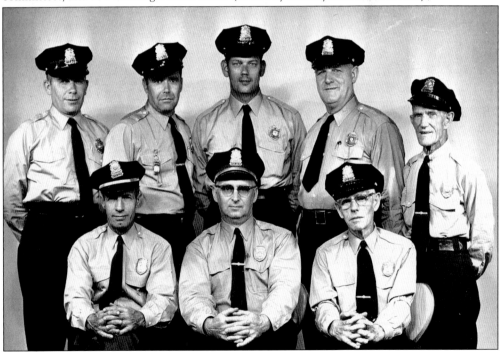

The Berkley constables and the police chief were elected to their positions. The men pictured here were those who served in 1961. Pictured are, from left to right, (first row) William Mitchell, Chief Harold Ashley, and William Cox; (second row) Merle Stetson, Arnold Perry, Robert Makepeace, Willis Craw, and Charles Harrison. (Courtesy Berkley Historical Society.)

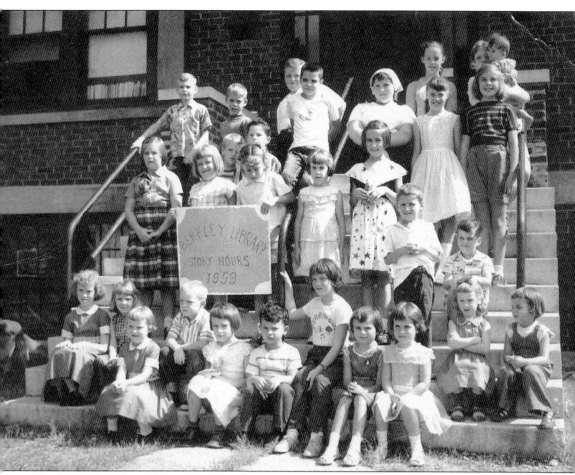

The library has always been popular with the children in town. Classes of students would walk from the Berkley Grammar School, just a short distance away, to the library to choose a book to read each week. A story hour was held in the summer at the Berkley Public Library from 1958 to 1971. Helen Craven was the librarian and organizer of the story hour, and Ruth Hyde took a picture of the children on the last day each year. Pictured are, from left to right, (first row) Nancy Cybulski, unidentified, Sandra Cybulski, unidentified, Mary Caron, Richard St. Yves, Gail Stetson, Eden Waterfield, Meryl Waterfield, Heather Holmes, and unidentified; (second row) Gail Bennett, Ann Fournier, unidentified, Rosemary Buckley, Irene Caron, James Caron, and Lawrence Stone; (third row) unidentified and unidentified; (fourth row) Raymond Stone, Douglas Stetson, unidentified, Frances Sylvester, Nancy Buckley, and June Stetson; (fifth row) Richard Stone, unidentified, Margaret Fournier, and Anne Caron. (Author's collection.)

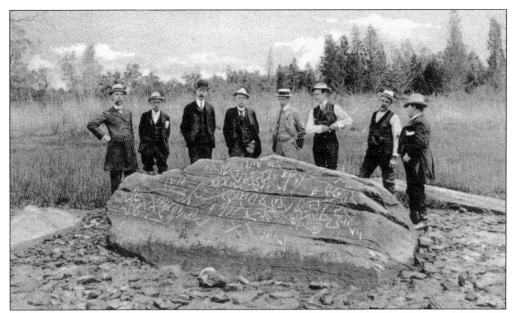

Dighton Rock, in the Taunton River, is called a "writing rock." Numerous markings are on the face of this 40-ton, 11-by-5-foot boulder. Various theories attribute the markings to the Norse, Phoenicians, Native Americans, Chinese, Portuguese, and others. Sketched in October 1680, by Rev. John Danforth, it has fascinated Americans including Cotton Mather, Ezra Stiles, and even George Washington. (Courtesy Merle J. E. Stetson.)

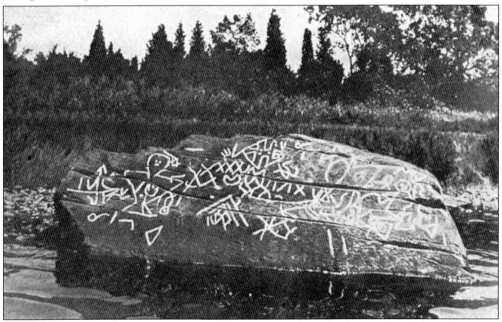

Dighton Rock was named while this section of Berkley, called Assonet Neck, was a part of the town of Dighton. Included in the various theories on the origins of the writings is that they were made by Portuguese explorer Miguel Cortereal in 1511. The rock, raised out of the river in 1963, is now housed in a museum at Dighton Rock State Park above its original location. (Author's collection.)

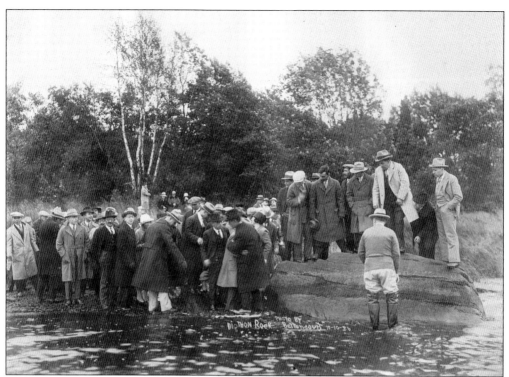

On October 10, 1926, Prof. Edmund Burke Delabarre (standing on the rock, wearing a white cap) and others gather at Dighton Rock. Delabarre, a noted historian, is the author of *Dighton Rock*. He first stated in 1918 that the writing included the date 1511. Through European research, he decided that the writings were created by Miguel Cortereal, a Portuguese explorer who was searching for his lost brother. (Courtesy Berkley Historical Society.)

The Taunton River forms the western town line of Berkley. All of Berkley was originally a part of Taunton. However, one section had become part of Dighton before becoming Berkley. Due to difficulty in crossing the river to attend church on the western side of the river, the inhabitants on the east side of the river formed the Town of Berkley in 1735. (Author's collection.)

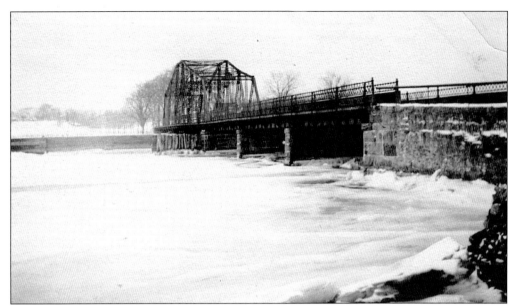

This winter view of a frozen Taunton River and the Berkley-Dighton Bridge was taken in 1918. This is the third bridge to span the Taunton River, formerly known as the Taunton Great River. The first bridge was a toll bridge built in 1801. The third bridge, built in 1896, is still in use today. (Courtesy Berkley Historical Society.)

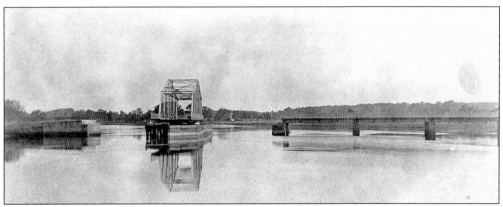

The Berkley-Dighton Bridge is a swing span bridge. When a boat wished to pass, the bridge tender would open the bridge, as viewed here, and boats could pass on either side. Originally opened by hand, it was later operated by electricity. More than once the bridge was stuck in the open position, and the bridge tender would have to swim back to land. (Author's collection.)

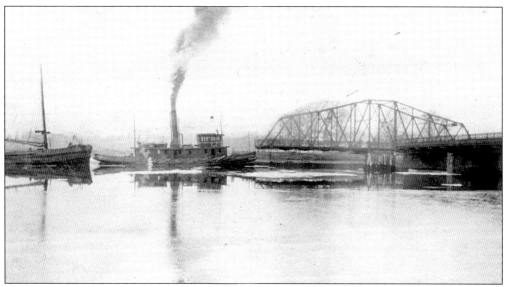

The Taunton River was used by boats that traveled to Taunton. Pictured here on January 10, 1924, is a Staples Coal Company tugboat passing the Berkley-Dighton Bridge on its way from Fall River to Taunton. The Staples Coal Company was located in the Weir section of Taunton. (Courtesy Berkley Historical Society.)

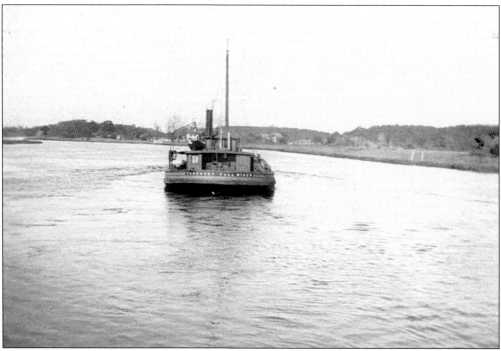

A tugboat travels along the Taunton River near the Berkley-Dighton Bridge in 1927. On the back of the tugboat, it reads "Somerset Fall River." Through this area of the Taunton River there were several large rocks that had to be avoided. The last person to open the bridge by hand was Milton Babbitt. (Courtesy Berkley Historical Society.)

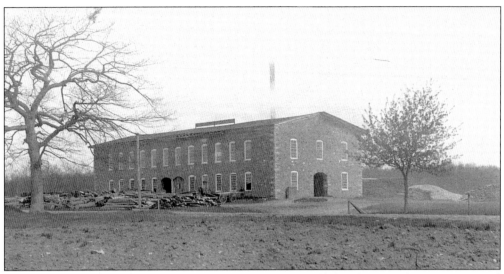

In 1858, this stone building was built as an exhibition hall for the Bristol County Central Agricultural Society. This society broke away from the Bristol County Agricultural Society feeling that Taunton, where the fair was held, was not in a central location. Exhibits were shown here with produce and handiwork among the items displayed. The last fair held in Myricks was in September 1876. (Courtesy Merle J. E. Stetson.)

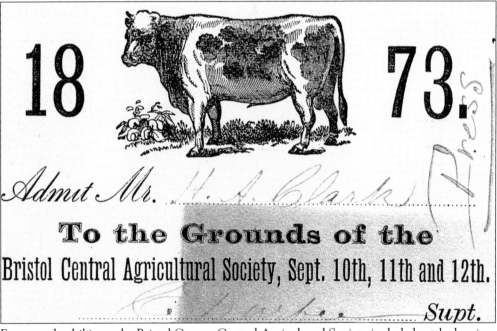

Events and exhibits at the Bristol County Central Agricultural Society included cattle drawing, horse races, and judging of vegetables, handiwork, and livestock. Shown here is a press pass to the fair. Band concerts were held as well as banquets. There were also vendors such as photographers and tables with lemonade, peanuts, fruits, and so on. It was reported that 6,000 people attended the fair in 1875. (Author's collection.)

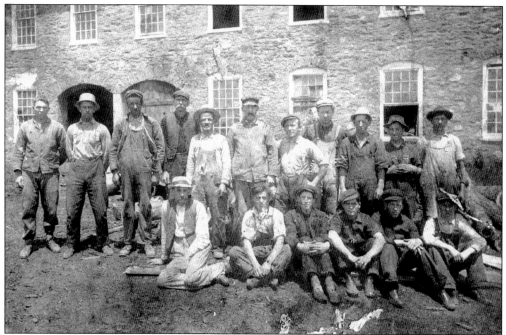

Pictured in front of the L. P. Churchill Box Factory are, from left to right, (first row, seated) Charles Farmer, unidentified, John Murphy, William Wambolt, Fred Allen, and John Ames; (second row, standing) Sanky ?, William Haskins, Art Mann, John Ames, John Summerskill, Burt Wordell, Frank Wambolt, Sandy ?, Alden Wilbur, George Ernest Westgate, and unidentified. (Courtesy Berkley Historical Society.)

In the 1930s, children had to come up with their own forms of entertainment. The children from Myricks participated in this parade, which was organized by Lawrence Stetson. Here the children are seen in costume, with their pets and wagons, marching on Mill Street in front of the mill. (Author's collection.)

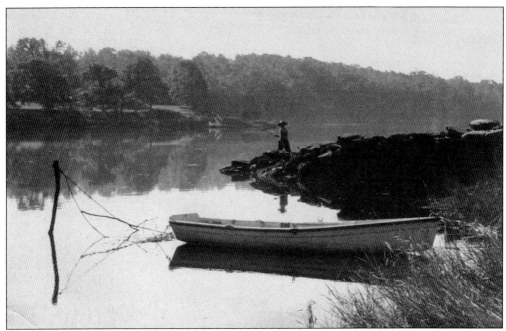

Seen in the photograph above is William Davis, who was fishing off a wharf on Grinnell Street. He was over 90 years old when this photograph was taken. At one time, fishing privileges sold for $250–$300 for the season when herring, shad, oysters, and clams were plentiful. The Taunton River and Assonet River surround the southern end of Berkley, making that part of town a peninsula. The peninsula is known as Assonet Neck. Below is a picture of Charles A. Davis, who is seen with a hoop fish weir. He was probably fishing in the Assonet River. The Davis family lived on Grinnell Street, which went from Bay View Avenue to the Assonet River. (Courtesy Berkley Historical Society.)

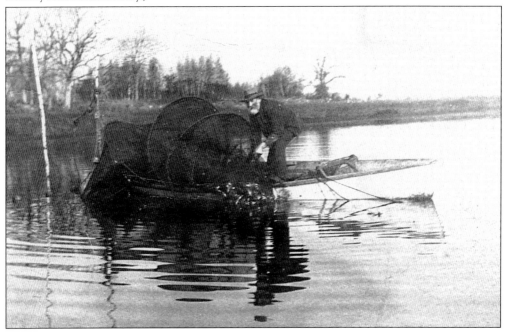

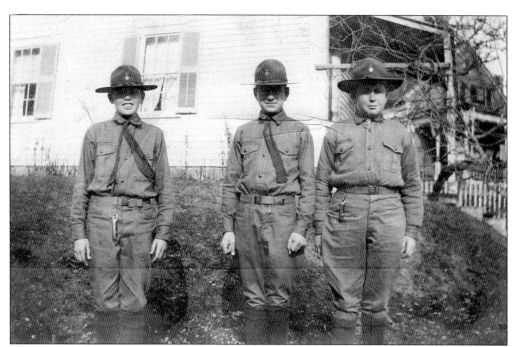

Boy Scouts from the Myricks Troop pictured here in 1927 are, from left to right, Henry St. Ours, Paul Crowley, and Gilbert Winslow. In 1925–1926, Rev. Manfred Carter was the leader and the Boy Scouts met at Grove Hall. Other leaders included Edward W. Winslow in 1928 and George W. Stetson in 1929. (Author's collection.)

In the early 1960s, Girl Scout leaders Nancy Gouveia (left) and Althea Stetson lead the troop that hiked from Berkley Common along North Main Street to the Hyde farm on Berkley Street. The girls enjoyed camping overnight at the farm as well as a nature hike, games, and a cookout. This picture was taken at the corner of Burt Street. Notice the street sign on the tree. (Author's collection.)

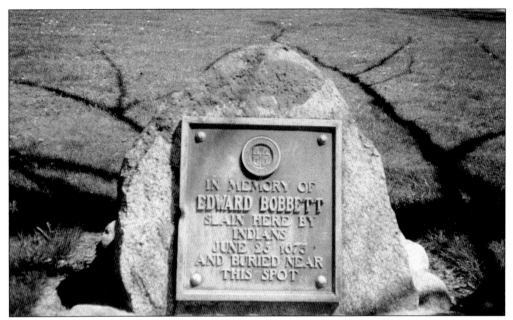

At the beginning of the King Philip's War residents of Berkley went to the safety of the garrison house. According to the story, Edward Bobbett's wife asked him to go home for her cheese hoop. During the trip, sensing there were Native Americans nearby, Bobbett climbed into a tree. Unfortunately his faithful dog stood looking up into the tree. A Native American noticed this and killed Bobbett. (Courtesy Berkley Historical Society.)

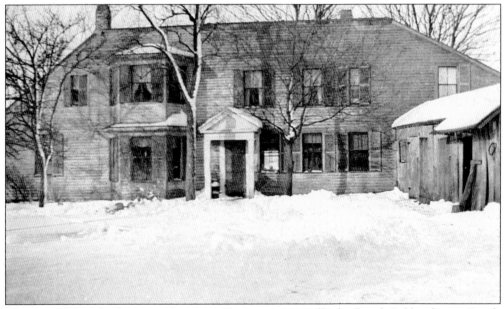

The Gene Whittaker homestead on Point Street was originally the Enoch Babbitt home. Enoch Babbitt was a descendant of Bobbett, who was killed by Native Americans on June 25, 1675, at the start of the King Philip's War. The house burned in the early 1930s. This house is mentioned in *An Old New England Home* by Merle Taft Barker. (Courtesy Berkley Historical Society.)

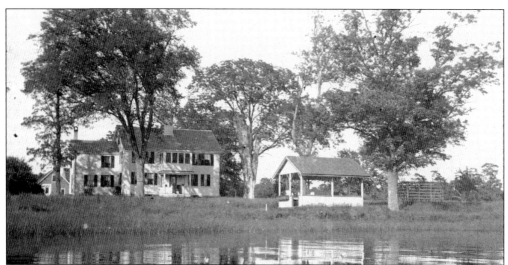

The house above is located along the Taunton River on Berkley Street. Originally the Abel Crane house, it was owned by John Crane in 1815. The house was owned by Adoniram Babbitt in 1871, and it was later owned by his son Rollin H. Babbitt, who was a member of the state legislature. During the 1938 hurricane, the water level rose nearly to the second floor. About 1795–1800, a panoramic view of the house and Taunton River was painted above the mantel of this house by Dr. Rufus Hathaway (1770–1822). The panel it was painted on measured approximately two feet by nearly six feet. Unfortunately it was removed and sold at auction in the late 1980s. To the right, about 1908, are Miriam Eleanor Babbitt (left) and Harriet Emeline Babbitt at the summerhouse. (Courtesy David R. and Jean E. Dean.)

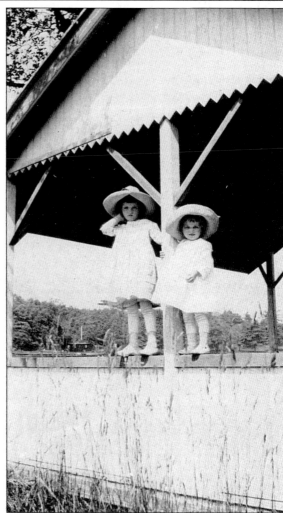

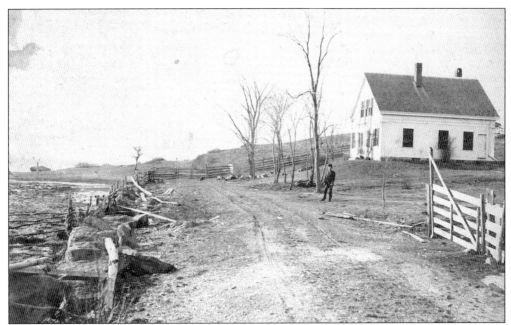

Charles Edward Carr is pictured at his farm on Bay View Avenue in 1880. Not far from this farm is where the Taunton and Assonet Rivers meet, creating Assonet Neck. It is said the Wampanoag Indians would meet on Conspiracy Island, located where the rivers meet, as it could be reached by foot at low tide and was an island at high tide, thus providing privacy. (Courtesy Berkley Historical Society.)

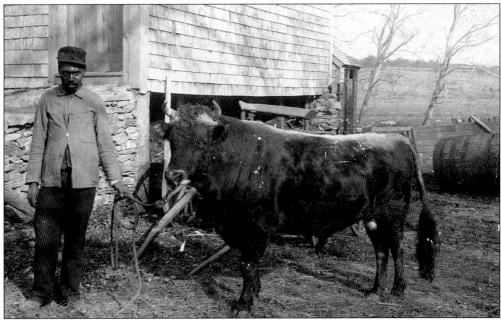

Ervine Chace owned this bull that no man could go near except for this one man, whose name is unknown. Farming and shipbuilding were the main occupations of the residents of Berkley for about the first 100 years after the town was organized. Ervine Chace served as town clerk from 1912 to 1945. (Courtesy Berkley Historical Society.)

John Freeman is standing on a load of hay for his cows. Freeman rented Dr. Dillingham's farm on Bay View Avenue from the early 1920s until the early 1930s. He would drive to Taunton to deliver the milk from his dairy to other farmers who had milk delivery routes. (Courtesy Heather Dropps.)

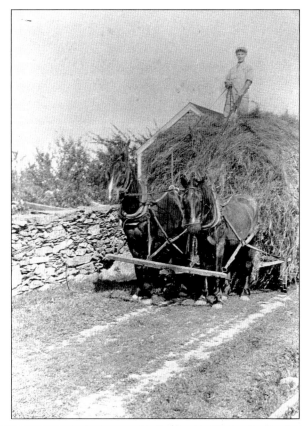

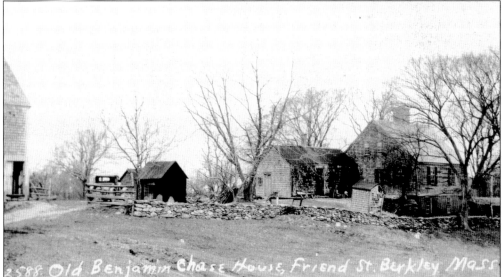

The old Benjamin Chase house was located on Friend Street. Stone walls, such as the one seen here, were common throughout town. The residents had to clear the stones from their fields in order to be able to grow their crops and pasture their animals. The walls were made while clearing the fields, and they were arranged to fence in the livestock. (Courtesy Freetown Historical Society.)

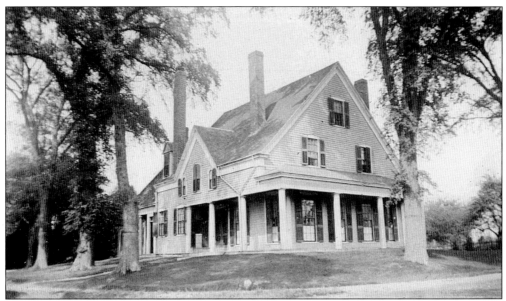

This house located at the corner of Padelford Street and Macomber Street was built in the mid-1800s by George Macomber, grandfather of Ruby Winslow Linn. Macomber ran a sawmill on Macomber Street on Cotley Brook. Pictured here in September 1936, the house still had the tall chimneys that were taken down by the 1938 hurricane. (Courtesy Berkley Historical Society.)

The Dean homestead, located on Macomber Street, was named Chardvelt as the Dean family came from Chard, England. The *velt* referred to the farm's orchards. When Edmund Dean owned the farm, he sold produce at Taunton and also shipped it to Boston and Fall River from the Myricks railroad station. Miriam (left) and Anthony Dean are sitting in the field across from the home about 1904. (Courtesy Eilene L. Atkins.)

Seen here, Douglas Stetson is riding Stormy, one of his cows, in the early 1960s. Stormy was born at the Stetson farm on Myricks Street during a thunderstorm in June 1961, and this is the origin of his name. Just like taming a horse, hours were spent in taming the cow. In the background is St. Yves Motor Sales. (Author's collection.)

One of Berkley's baseball teams is pictured here. Baseball was a popular activity in the early 1900s. There were other teams in town, including teams in Myricks. Tennis was also a popular sport in the 1900s, with courts being built in Myricks where the St. Yves Memorial Park baseball field is now located. (Courtesy Berkley Historical Society.)

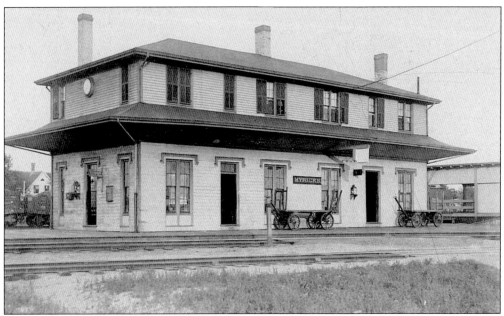

The railroad depot at Myricks was a very busy station. It was built by the New Bedford and Taunton Railroad and the Fall River Railroad. Trains began running through Myricks in 1840. The rails split at Myricks with tracks leading to Taunton, Fall River, New Bedford, and Middleborough. In the depot were separate waiting rooms for men and women. The depot was torn down in the mid-1940s. (Author's collection.)

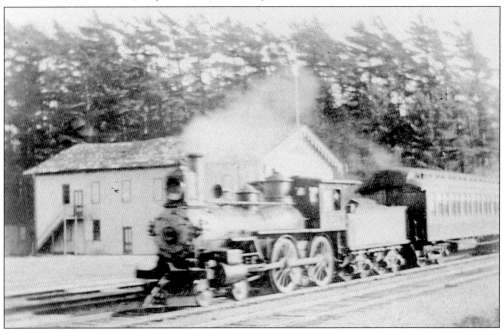

Railroad Hall was located just south of the merchandise depot and passenger depot at the Myricks railroad station. Adjacent to the hall was a pine grove park with a brook, pond, bandstand, and swings. Excursion trains brought up to 2,000 people to Myricks to enjoy activities at this hall and park. "All Aboard for Myricks!" (Author's collection.)

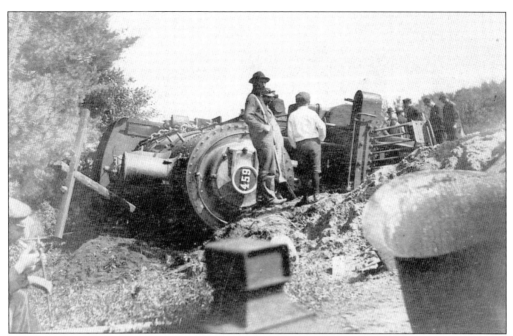

There were several train accidents in Myricks. This accident occurred on June 12, 1908, near the wye, where the Fall River and New Bedford tracks split. The passenger train from Fall River, headed to Boston, hit a misplaced switch and derailed. No one was hurt. At the wye were four houses, all built with the same plan. They were called the "Four Sisters." (Courtesy Merle J. E. Stetson.)

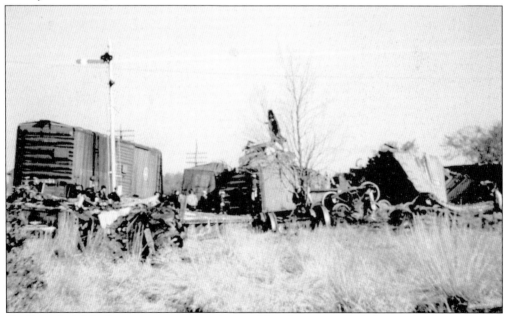

On June 5, 1956, the most recent derailing at Myricks occurred. A loose wheel on a boxcar caused the train to derail. An automobile stopped at the crossing was overturned, but fortunately no one was seriously injured. The switching station had a portion of its walls torn away, and the switches were damaged. (Courtesy Berkley Historical Society.)

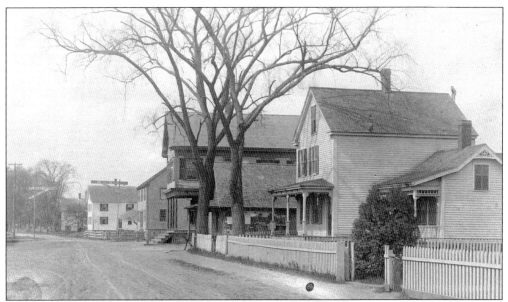

This is a picture of Myricks Street about 1900, looking toward Assonet. The building with the steps leading to the road was the Macomber Store. At one time, the store was operated by George R. Macomber and Pardon Manchester. Later it was run by Macomber's father and grandfather Rufus and Restcome Macomber. The post office was located here after the Luther Store burned. (Author's collection.)

Rufus Macomber is standing in the back of the Macomber Store. The store was built in the 1850s by Gideon H. Myrick. It had numerous owners, including George S. Macomber, Benjamin Taylor, George R. Burt, Benjamin S. Haskins, Pardon Manchester, George R. Macomber, Rufus Macomber, and Restcome Macomber. The last owner was Peter Trenouth. The store was destroyed by fire on June 1, 1923. (Courtesy Merle J. E. Stetson.)

The Luther Store is the largest building in this picture. It was located on Myricks Street near Grove Street. The store was run by George Luther, who was killed in 1917 when he was hit by a train. The Luther Store was destroyed by a fire on November 15, 1922, as was the house next door. In the background is the Myricks Methodist Church parsonage. (Courtesy Merle J. E. Stetson.)

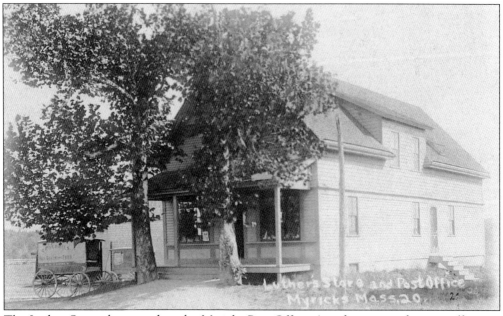

The Luther Store also served as the Myricks Post Office. At other times, the post office was located at the railroad station, private homes, the Macomber Store, and, for a time, in its own building. The post office in Myricks was open from May 9, 1848, until May 1924. Asahel Stockwell was the first postmaster, with Calvin Myrick following him. Martha Hicks was the last postmaster. (Courtesy Lakeville Historical Society.)

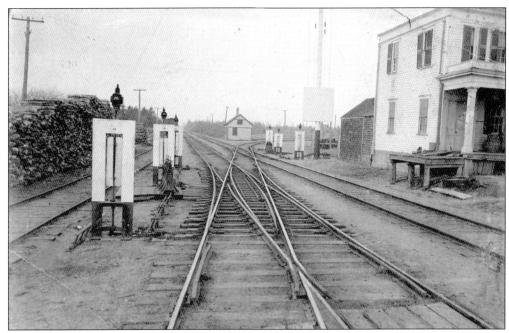

This view taken from the Myricks railroad crossing shows the rail to Taunton straight ahead and the rail to Middleborough branching to the right. The Macomber Store is at the right of the picture. Straight ahead is a section house where handcars and tools were stored. At the left is wood waiting to be loaded on cars to be taken to cities for use as firewood. (Author's collection.)

Grace Jones and her daughter Mary are standing on the front lawn of their home at the corner of Myricks Street and Mill Street. This was later the home of Edward and Lena Winslow. During World War II, there was a grocery store in the little building at the right in the picture. (Courtesy Merle J. E. Stetson.)

As a young man, Silas Edgar Brailey moved to Cripple Creek, Colorado, to work at the gold mine of his brother Henry C. Brailey. During the Spanish-American War, he joined the 7th Regiment U.S. Infantry Company A. After the war, he returned to Massachusetts. He worked at the L. P. Churchill Box Factory. Brailey was elected selectman in Berkley many years between 1929 and his death in 1945. (Author's collection.)

The Myrick homestead, on Myricks Street, was the home of several generations of the family for which Myricks was named. The house and property were sold to the Bristol County Central Agricultural Society in 1862. Pictured in front of the house, about 1896, is George R. Macomber, and to his left are his wife, Eliza (Brailey), and his daughter, Grace. The others in the picture are unidentified. (Author's collection.)

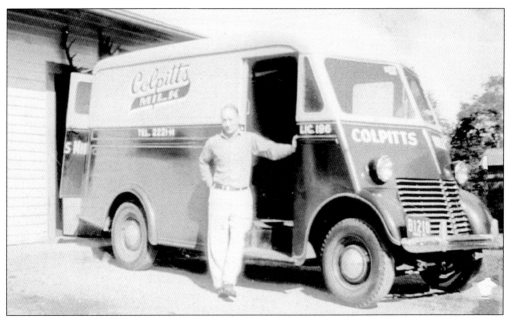

Colpitts Dairy delivered milk within Berkley and to other towns such as Dighton, Somerset, and Fall River. Wendell Conant, pictured here, was one of their deliverymen. At other times, Conant worked for the town's highway department, drove a school bus, and served as town tax collector. (Courtesy Berkley Historical Society.)

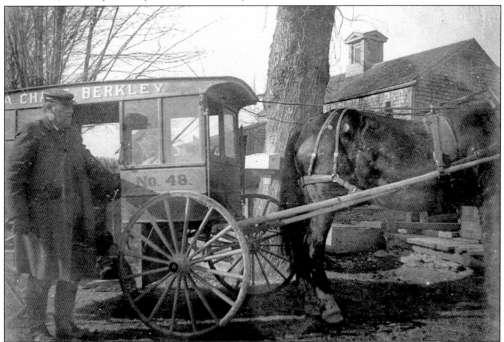

Ervine Chase is pictured in front of his dairy wagon. His dairy was located on North Main Street between Burt Street and Berkley Street. Chase served the town as town clerk from 1912 until 1945. There were several other dairies in town that delivered milk, including Townley, Dow, Colpitts, Sellars, Roman, and Victurine. (Courtesy Berkley Historical Society.)

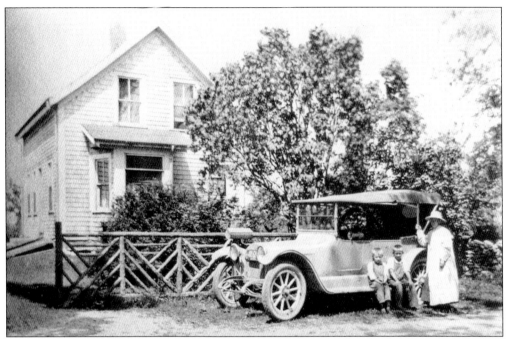

Arnold (left) and Eino Silvan sit on the running board of the family car while their mother, Elna, looks on. Arnold was active in the volunteer fire department for many years, and he was one of the men instrumental in the building of a fire station in Myricks. Eino was a longtime selectman in town. (Courtesy Eilene L. Atkins.)

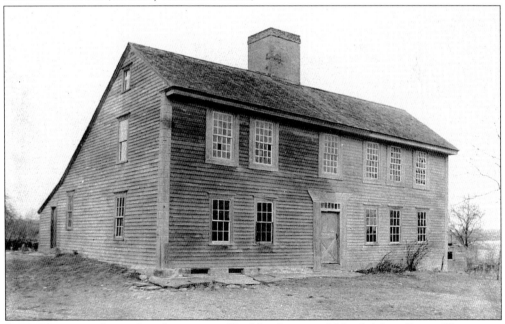

Burt's Tavern was located at the corner of Berkley Street and North Main Street. The tavern was run by Abel Burt around 1800. Julia Dean was the owner of the house in October 1929, when this picture was taken. The original tavern sign, when it was French's Tavern, can be seen at Old Colony Historical Society in Taunton. (Courtesy Berkley Historical Society.)

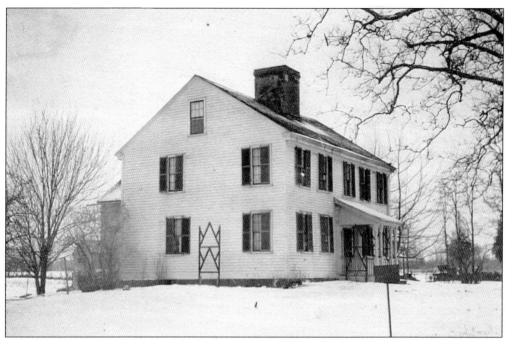

The Samuel Tobey homestead was located on Berkley Common. Tobey moved into the house on October 31, 1738. He was the first minister in Berkley, preaching until he died in 1781, a short time after he fell from his horse. The house is pictured here in February 1918. It was demolished in 1960. A plaque marks this historic spot. (Courtesy Berkley Historical Society.)

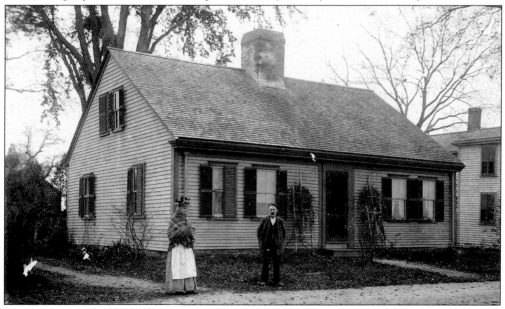

This house on Elm Street, located near the Berkley Bridge, was owned by James and Harriet (Babbitt) Maguire, who are pictured here standing in their front yard in 1896. This section of town was formerly known as Bridge Village. In the village were the Bridge School and a chapel, which was located on Elm Street near where Wallace Street is located today. (Courtesy David R. and Jean E. Dean.)

According to the Camp Fire Girls' *The Record Book of the Ampu Tal Tali Camp Fire*, on "April 18, 1925, Our meeting was held at the [Myricks] schoolhouse. We caned chairs and made sealing wax, salt and pepper shakers, vases and candle sticks. Being hot in the school house we took the things out doors and worked in the shade." Miriam Ashley was the guardian, and Mildred Ashley was the assistant guardian, with members including Minnie Clark, Hilda De Costa, Alice Gagnon, Concorde Gagnon, Eva Gagnon, Irene Gagnon, Beatrice Haskell, Viola Parris, Ruby Winslow, Lillian York, Rita York, May Bosworth, and Ermelinda Souza. The picture below was taken at the Dean cottage near Dighton Rock. (Courtesy Miriam Phyllis Bush.)

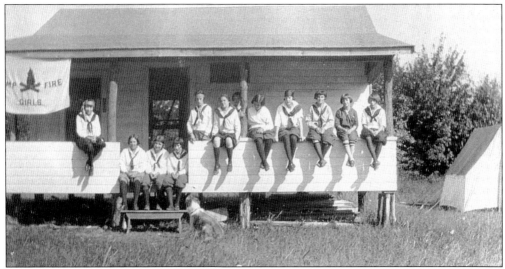

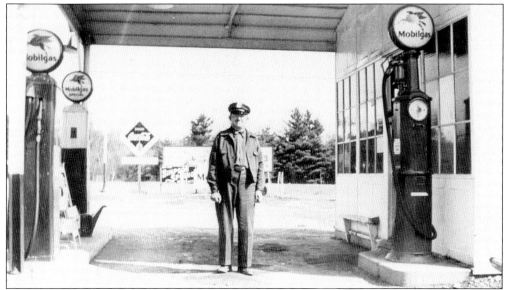

Sumner Staples opened Staples Gas Station on September 2, 1911. It was the first gas station in Bristol County. Later his son, Calvin, who is pictured here, ran the station. Calvin sold the station in 1952 to Edmond B. and Rene E. St. Yves. The station was located at the corner of Myricks and County Streets. This corner came to be known as Staples Corner. (Courtesy Eilene L. Atkins.)

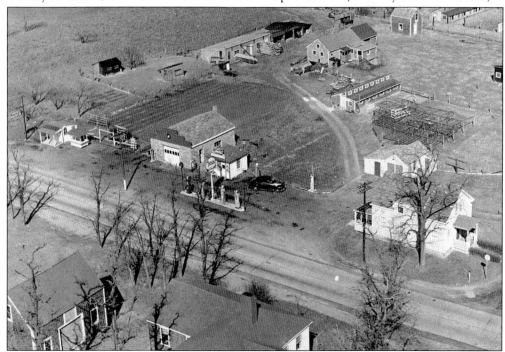

Joseph Tavares owned the farm and gas station pictured here in the 1940s. They were located at the corner of Myricks Street and County Street, diagonally opposite Staples Gas Station. At the left is the stand where Tavares sold vegetables. The smaller stand was portable. Near the center are his grape arbor and a chicken house. In the foreground is the home of Sumner Staples. (Courtesy Berkley Historical Society.)

Calvin Staples sold his gas station to Edmond B. and Rene E. St. Yves in August 1952. They made an addition to the building and began selling used automobiles. This photograph was taken on October 18, 1959. There were billboards on each side of County Street at the end of their lot and another pair past the intersection headed toward Taunton. (Courtesy Richard E. St. Yves.)

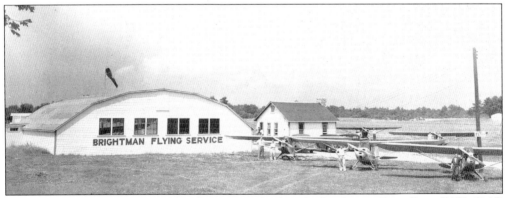

The Myricks Airport, at 168 Padelford Street, was built at the Brightman Dairy Farm (1932–1946) by John Brightman. It has a grass runway. It was an approved primary flying school (1946–1954). Over 300 veterans learned to fly here under the GI Bill of Rights. Pictured in 1948 are, from left to right, (foreground) Paul Chatterton, Raymond Custy, Benjamin Rose, and Fred Chew; (background) unidentified, John Brightman, and Del Kendzierski. (Courtesy Murray Randall.)

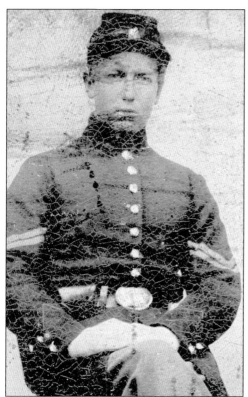

Levi Crane entered the service in 1861 and served in the Civil War until 1864. He participated in many battles, including the siege of Yorktown, Hanover Court House, Mechanicsville, and Second Bull Run. He was injured several times, including at the Battle of Fredericksburg in 1862, when he was severely wounded. He left his Civil War items to the Berkley Public Library. (Courtesy Berkley Historical Society.)

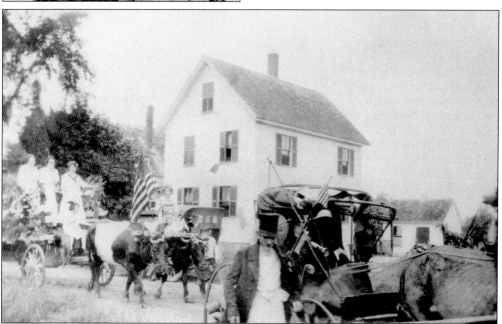

A Fourth of July parade was held probably in 1919, right after World War I. Shown here is the parade as it passed the Ames home on Myricks Street near the railroad crossing. Wearing the stovepipe hat is Edmund Porter Dean. Notice the oxen pulling one of the wagons. (Courtesy David R. and Jean E. Dean.)

According to the "Annual Reports of the Town Officers of the Town of Berkley" in 1919, the town appropriated a sum of $400 for a welcome home celebration for the soldiers returning from World War I. The appointed chairman of the committee was Joseph Howland. The parade pictured here may have been part of the welcome home. In the photograph above, standing to the right of the United States flag is Ada Dean. In the photograph to the right, riding the horse is Edward Winslow. Winslow was the stationmaster at the Myricks railroad station. (Courtesy David R. and Jean E. Dean.)

The Myricks Around the Table Book Club was organized in September 1914. There were 12 members who each purchased two books a year, and the books would be rotated to another member semimonthly. Later they purchased one book a year. The last meeting was held on September 10, 1988. Pictured are, from left to right, Rita York, Mildred Lang, Harriet Hunter, Amelia Johnson, and Marian Stetson. (Author's collection.)

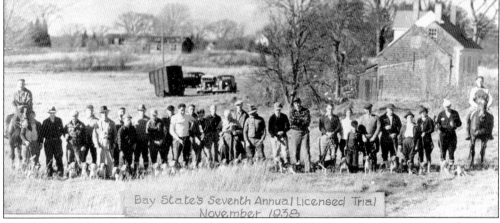

The Bay State Beagle Club was started in 1932. It owns 125 acres on Point Street that can never be sold. The club holds field trials, sanction trials, and shows for American Kennel Club beagles. It competes against clubs in other parts of Massachusetts, as well as Rhode Island and Connecticut. (Courtesy of Bay State Beagle Club.)

Two

FREETOWN

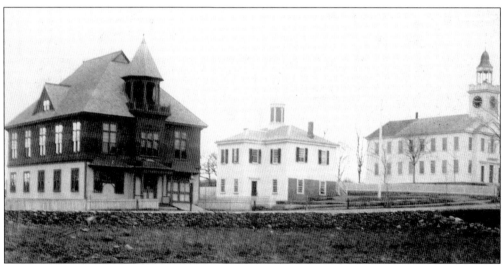

Freetown Town Hall was built on North Main Street in 1888. A sum of $4,500 was appropriated to build and furnish the hall. When the project was completed, there was $4 left over. Hand-drawn fire trucks were stored in the garage at the front of the town hall, and then motorized trucks were kept there until 1947. Next door are the Village School and the North Congregational Church. (Courtesy Freetown Historical Society.)

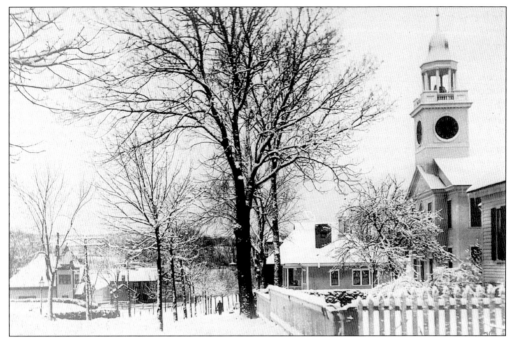

A scenic winter view was taken about 1900, looking down Taunton Hill toward Assonet Four Corners. The North Congregational Church, Village School, and town hall are at the right, and the Guilford H. Hathaway Library is on the left of the picture. Located on North Main Street, this area was known as Taunton Hill. (Courtesy Bob Dorsey, Winter Hill Antiques.)

A blast furnace was built in East Freetown near Fall Brook about 1784. Bog iron from Lake Assawompset was smelt at the furnace. In 1814, the furnace was the town's largest employer with over 50 workers. In 1818, the blast furnace was replaced by a cupola furnace. Remains from the furnace are pictured here about 1900, and some remains are still there today. (Courtesy Freetown Historical Society.)

50

Ye Freeman's Purchase, later named Freetown, was transferred in 1659 from Chief Wamsutta and his squaw, Tattapanum, to 26 purchasers. The 23rd lot was owned by John Tisdale and settled by his son Joshua. On this lot was a natural rock formation that looked like a Native American. It is also known as Joshua's Mountain and Profile Rock. It is located in Freetown-Fall River State Forest. (Courtesy Bob Dorsey, Winter Hill Antiques.)

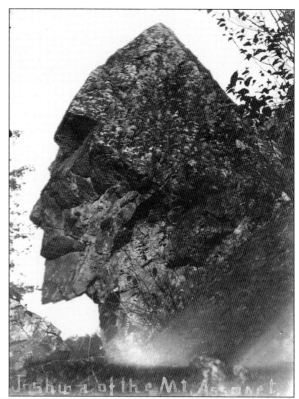

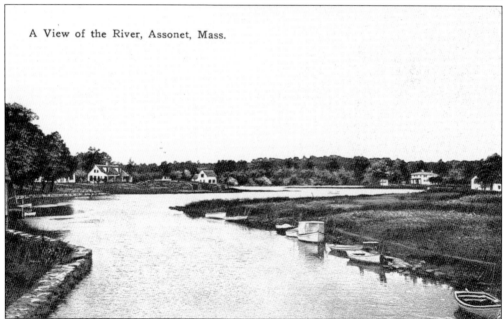

A View of the River, Assonet, Mass.

The Assonet River was a busy seaport in the 1700s and 1800s. In addition to being active in shipping commerce, shipbuilding was an important business in Freetown. The first vessel was recorded as being built in 1782. The last boat was built in 1848. During that time, over 250 sailing vessels, sloops, and ships were built. (Courtesy Bob Dorsey, Winter Hill Antiques.)

John M. Deane was born in this house. Deane moved the house to Water Street, where it is seen in this photograph taken in 1896. The catboat, with the width of the boat being equal to one-half its length and having a round hull, was used for recreational sailing. Today this is the site of the town park and is named Hathaway Park. (Courtesy Freetown Historical Society.)

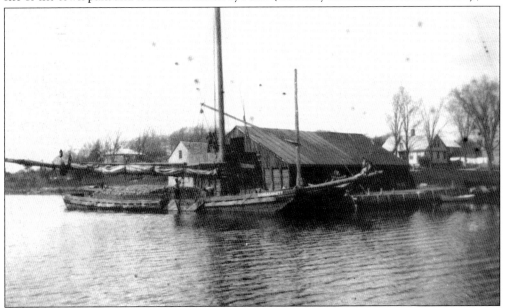

The Cudworth and Davis Wharf was one of many wharves located along the Assonet River at the village of Assonet. A coal yard was located at this wharf. Coal was brought into Assonet from Perth Amboy, New Jersey, and places in Pennsylvania. The coal barge pictured here at the foot of Pleasant Street has a leeboard instead of a keel. (Courtesy Freetown Historical Society.)

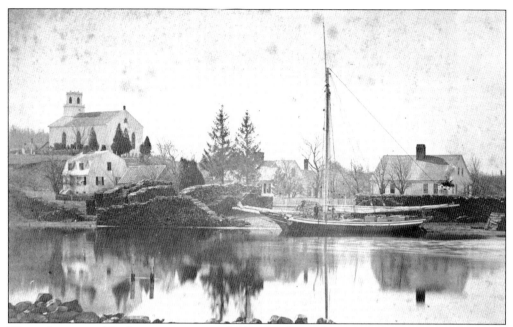

These ships out of Dighton were among the last loaded with cordwood in Assonet. The wood was taken to cities like Newport and Providence that burned wood in the summer and coal in the winter. This view was taken facing the Lane. The Christian Church in Assonet sits on the hill overlooking the Assonet River. (Courtesy Freetown Historical Society.)

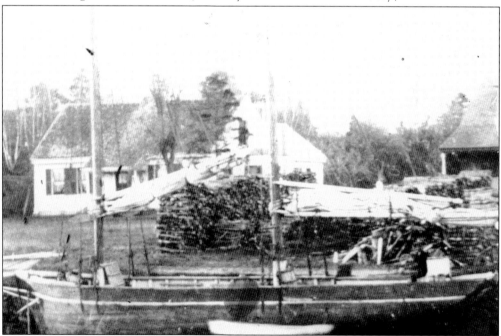

This boat on the Assonet River was waiting to be loaded with some of the cordwood pictured in the background. Notice in several of the pictures from the beginning of the 20th century that there were few trees left in some parts of town, as the trees had been cut for cordwood. (Courtesy Freetown Historical Society.)

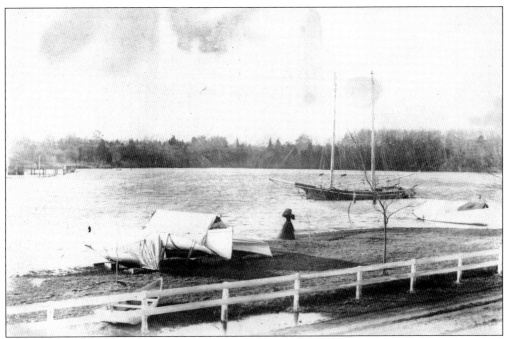

Maryann (Annie Mary) Leebrin was looking out at the schooner *Addie Randall* prior to 1902, when it was broken up. The *Addie Randall* was a 40-ton vessel owned by Alfred B. Davis, who was also the master of the schooner. It was the last vessel to hail from Freetown. (Courtesy Freetown Historical Society.)

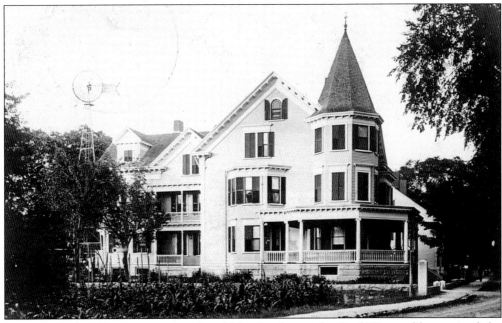

Maj. John Milton Deane was engaged in 20 battles during the Civil War, and he received the Medal of Honor for his service. After the war, he ran a market in Fall River that was about the size of a city block. He built his home on Water Street in 1896–1897. The Assonet Inn has operated in this house since about 1945. (Courtesy Bob Dorsey, Winter Hill Antiques.)

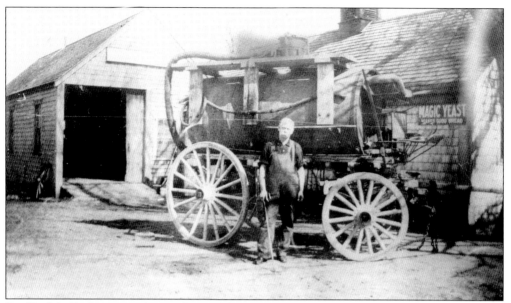

Bradford A. Braley is standing in front of the town's water wagon in the early 1900s. The water wagon was used to settle dust on the dirt roads. The picture was taken in front of Horatio A. Braley's Blacksmith and Carriage shop at 15 Washburn Road. Horatio A. Braley was a member of the state legislature. (Courtesy Freetown Historical Society.)

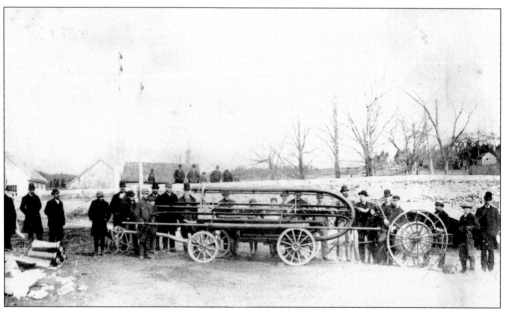

After a large fire on October 5, 1886, the fire engine *Narragansett* was purchased from Warren, Rhode Island, for $800. This is a picture of a demonstration of the engine that was held about 1887. A demonstration of the first motorized engine occurred at the same spot in 1925. The *Narragansett* is on display at the Freetown Historical Society. (Courtesy Freetown Historical Society.)

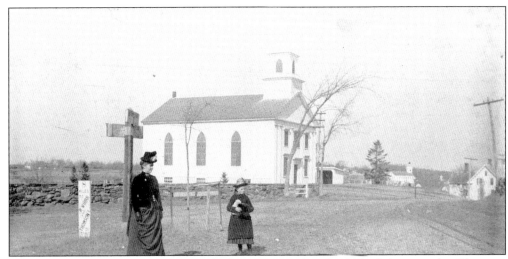

This church was a Baptist church in the late 1700s and early 1800s. It became the Christian Church in Assonet about 1832. The building was replaced in 1833 and remodeled in 1895. The church is currently St. Bernard's Catholic Church. It is located on South Main Street near the intersection of High Street. (Courtesy Freetown Historical Society.)

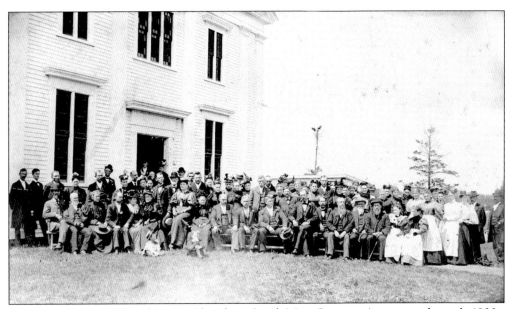

This is a gathering at the Christian Church on South Main Street in Assonet in the early 1900s. In past centuries, church gatherings were a favorite activity of the citizens of the town. Activities included church suppers, fairs, men's and women's societies, and activities for the youth of the community. (Courtesy Freetown Historical Society.)

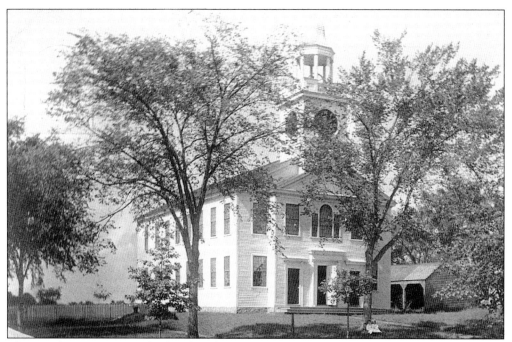

The North Congregational Church is located north of the town hall on North Main Street. The church was built in 1809 by Ebenezer Peirce of Lakeville. The clock was purchased from Amherst College in 1882. A Paul Revere bell is in the tower. This is a view of the church about 1900. (Courtesy Bob Dorsey, Winter Hill Antiques.)

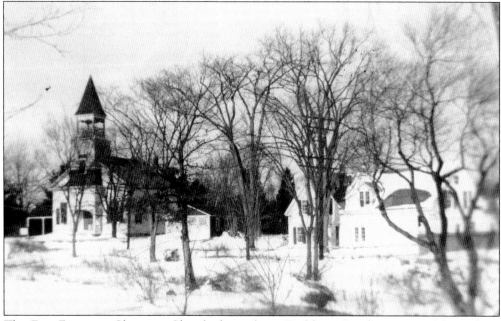

The East Freetown Christian Church, located on Washburn Road, is pictured here about 1940, which is the year it became the East Freetown Congregational Christian Church. The carriage shed can be seen at the left of the picture. In the foreground is Fall Brook. (Courtesy Melanie Dodenhoff.)

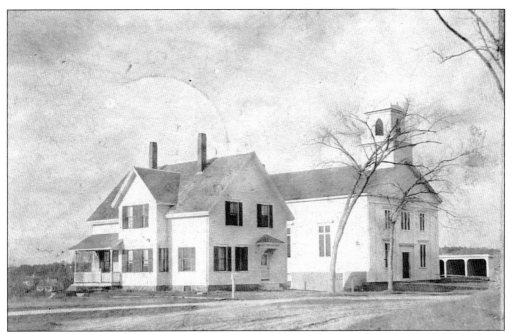

The Christian Church in Assonet built its parsonage in 1895. The parsonage is still in use, and the horse sheds on the other side of the church are still there. This view vividly shows the lack of trees in the area at the beginning of the 20th century. (Courtesy Bob Dorsey, Winter Hill Antiques.)

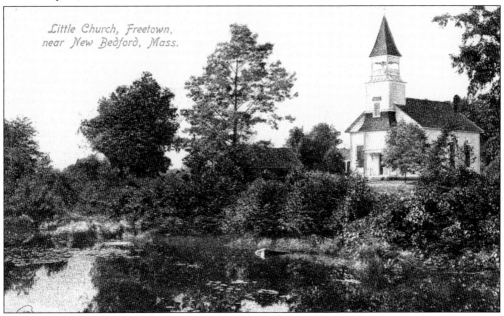

Little Church, Freetown, near New Bedford, Mass.

The East Freetown Congregational Christian Church was built in 1888 by Abial Ashley. It was designed by Clothier Edminster. In the 1880s, the Ladies Friendly Circle helped raise money needed for the building of the church. When the church was dedicated, it was debt free as the members donated the materials and labor. The Ladies Friendly Circle is still active today. (Author's collection.)

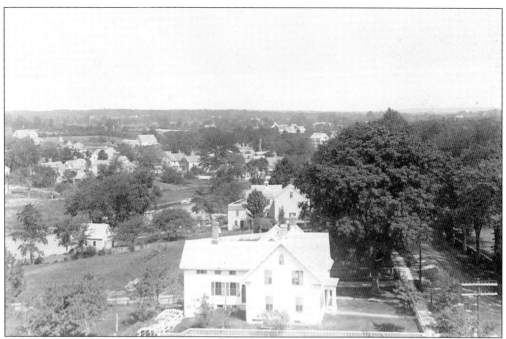

A bird's-eye view of Assonet village is provided in this photograph taken from the steeple of the Christian Church in Assonet. This view is looking toward town hall. In the center is John Peabody's house, which is located at the corner of the Lane and South Main Street. (Courtesy Bob Dorsey, Winter Hill Antiques.)

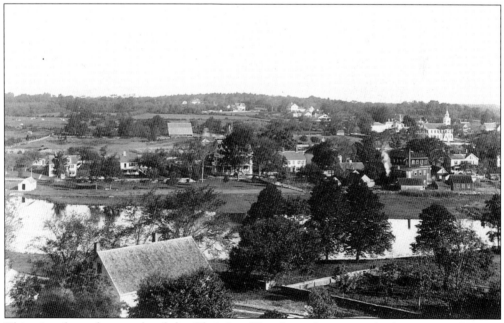

This view from the steeple of the Christian Church in Assonet was taken just to the west of the picture shown above. The Assonet River can be seen in the foreground. The North Congregational Church and Davis Gun Factory are seen on the right side of the picture. (Courtesy Bob Dorsey, Winter Hill Antiques.)

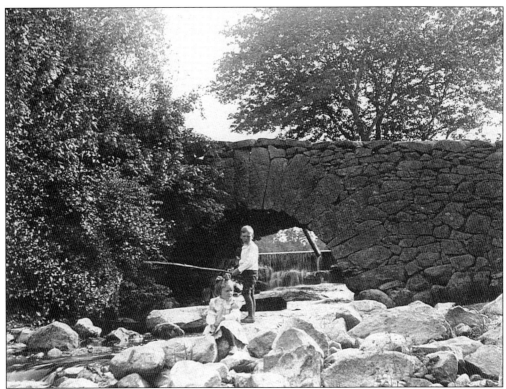

Death Curve Bridge on County Road spanned Fall Brook. It was a single-arch stone bridge. It was built by Capt. Malachai Howland in 1822. Playing along the edge of Fall Brook are Hazel and Orrin Swift. The bridge, also known as Dead Man's Curve Bridge and Death's Curve Bridge, was replaced in 1921 and remodeled in 1941. (Courtesy Melanie Dodenhoff.)

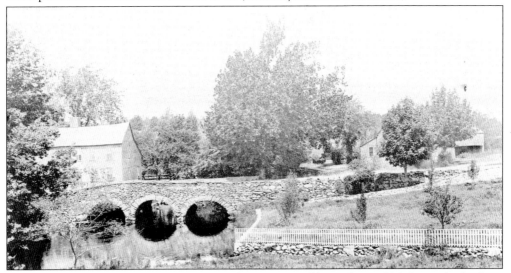

The Elm Street Bridge with three stone arches is pictured here about 1900. It was built about 1823. This bridge, also known as the East Bridge, is still in use today. The house of John D. Wilson, owner of the Wilson Saw Mill, is seen behind the bridge on the left side of the picture. (Courtesy Freetown Historical Society.)

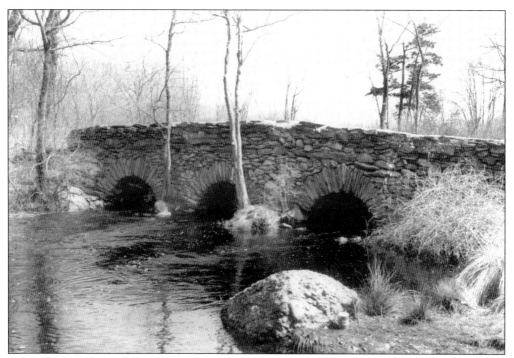

Maple Tree Bridge, or Maple Tree Crossing, is one of two triple-arch stone bridges in Freetown. It spans the Assonet River on Richmond Road. There was a dam located here, built in 1825, to run a gristmill. In 1865, it became a sawmill. In 1872, Julius C. Haskins bought the mill, and in 1887, John T. Haskins owned and ran the mill. (Courtesy Freetown Historical Society.)

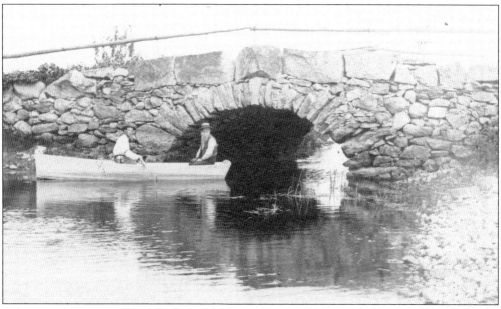

Fishing at the Gurney Road Bridge in the late 1800s are William T. Chace (left) and Charles Bosworth. This spot on Fall Brook near the Mill Pond was popular for catching pickerel. At the time of the American Revolution it is said there was a peach orchard where the Mill Pond is today. (Courtesy Freetown Historical Society.)

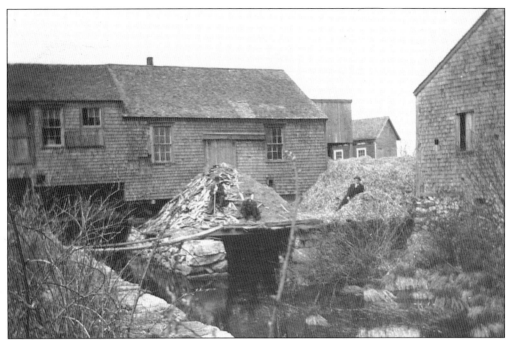

This sawmill on Fall Brook in East Freetown was also a sash and blind factory at one time. It was located on Washburn Road, the heart of East Freetown commerce, in front of the cupola furnace. In the piles of shavings pictured are, from left to right, brothers Wallace, Bradford, and George Braley. Dr. Braley Road was named for their grandfather Dr. Bradford Braley. (Courtesy Melanie Dodenhoff.)

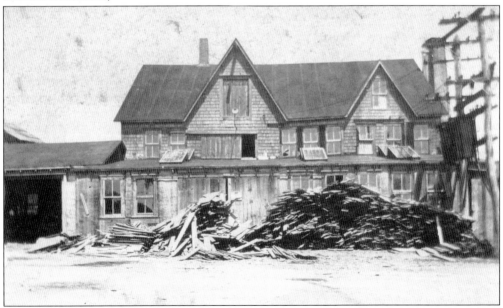

The East Freetown Sawmill Company, located on Chace Road, was run at one time by Elijah and Frederick Chace. It was a sawmill and later a box factory. As early as 1918, the mill was run by the Waterman family. In 1934, they stopped using the mill, and the building was gone soon afterward. (Courtesy Freetown Historical Society.)

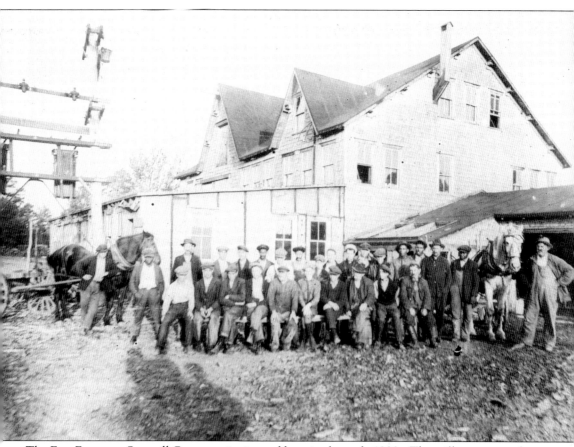

The East Freetown Sawmill Company is pictured here in the early 1900s. The mill was powered by Fall Brook as were several other mills along the river. The mill had electricity by 1918. This company was one of the largest employers of the residents of East Freetown. Other industries in town included the Puritan or Swiss Textile Mill started about 1910, at the corner of Mill Street and Locust Street. It processed cotton. Later the Monument Manufacturing Company made textiles such as quilts, sleeping bags, and pot holders in this building. It was a world-leading manufacturer of quality quilts. Up to 175 people were employed here. (Courtesy Freetown Historical Society.)

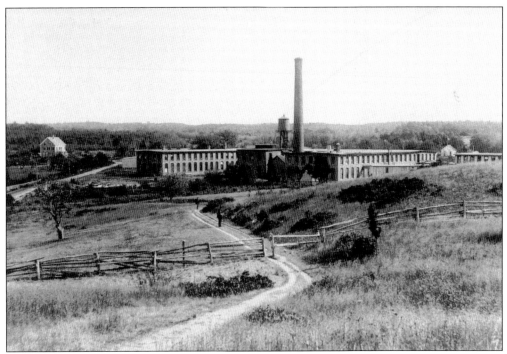

The Crystal Springs Bleachery and Dying Company textile complex was located at the corner of South Main Street and Narrows Road in the Assonet section of town. The bleachery was built about 1882 by John Thorp, who died soon after the building was finished. The company was the town's largest employer, with around 200 workers. The mill was closed a few times, and then it would be reopened under new management. A huge fire on December 14, 1955, completely destroyed the building despite the fact that help had been obtained from the other area towns. (Courtesy Freetown Historical Society.)

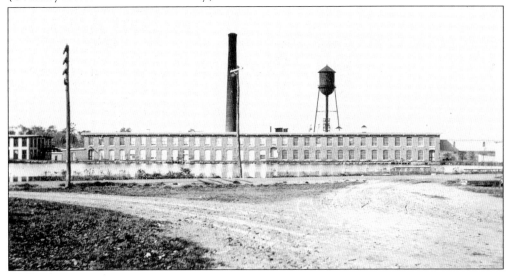

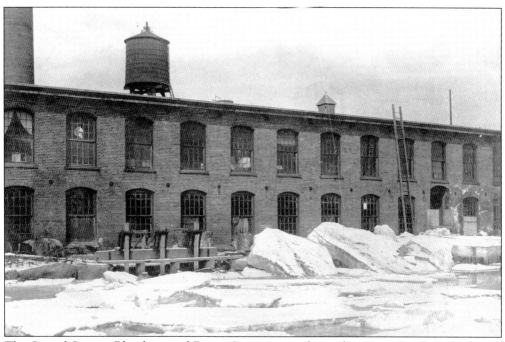

The Crystal Springs Bleachery and Dying Company was located on Terry Brook at the corner of South Main Street and Narrows Road in Assonet village. It operated under other names including Crystal Springs Finishing Company, New England Print and Dye Works, and Terry Bleachery Manufacturing Company. About 1901, the dam on Terry Brook broke when the ice began to melt, and huge chunks of ice slammed into the building. Below is a view of the upper pond after the washout. A large pond was formed at the dam, which was a popular spot for ice-skating. Terry Brook originates in Freetown-Fall River State Forest and empties into the Assonet River. (Courtesy Freetown Historical Society.)

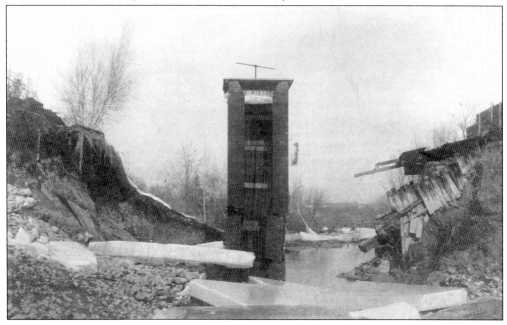

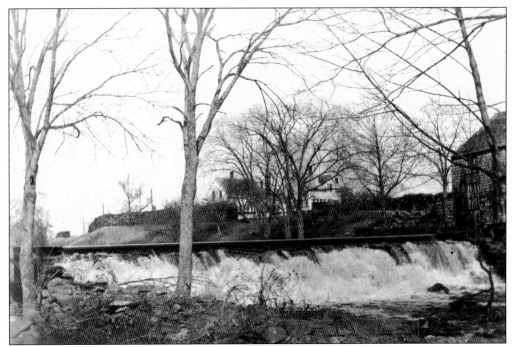

The Tisdale Dam at John D. Wilson's gristmill was one of more than 19 dams built on Assonet River, Mill Brook, Terry Brook, and Fall Brook. The dams were used to power sawmills, gristmills, and iron works. The first dam was built about 1695. The Tisdale Dam is at the corner of Mill Street and Elm Street. (Courtesy Freetown Historical Society.)

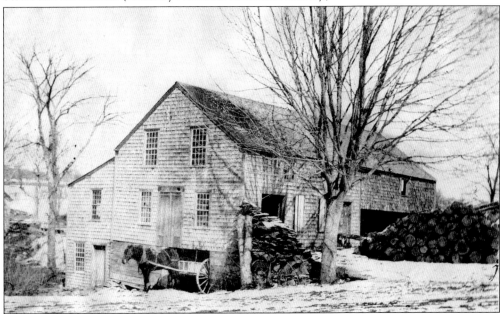

Through the years, at least 10 dams have been constructed along the Assonet River. The rushing water was used to provide power to run the sawmills and gristmills that were vital to the local economy. Seen here behind the John D. Wilson mill is one of the dams. (Courtesy Freetown Historical Society.)

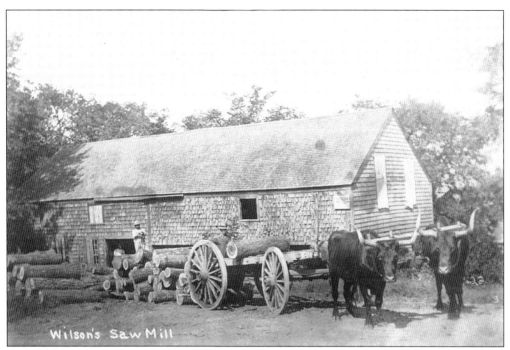

Wilson's Saw Mill

A sawmill was located at the corner of Elm and Mill Streets on the Assonet River. It was owned by Job Pierce about 1810. The mill was run by John D. Wilson from about 1850 to 1902. Joaquin Rezendes ran the mill after Wilson died. Yoke of oxen were commonly used for pulling the heavy wagonloads of logs. (Courtesy Bob Dorsey, Winter Hill Antiques.)

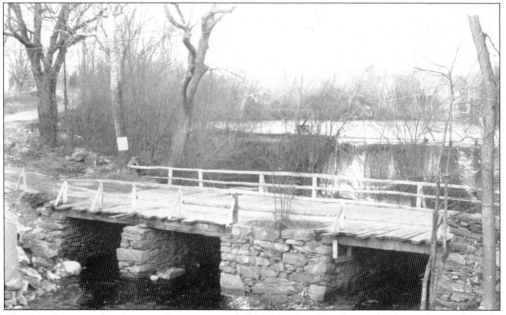

The first dam on the Assonet River was probably the Winslow dam, which was located beside Locust Street. It was built about 1695, and it remained in use for about 200 years. At first a sawmill operated here, and later other mills were built at the dam, including a fulling mill and a gristmill. (Courtesy Freetown Historical Society.)

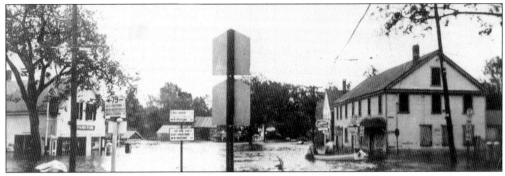

Hurricane Carol hit Freetown on August 31, 1954. In the aftermath of the storm, the water from the Assonet River flooded Assonet Four Corners. As seen here, boats were used to navigate through Assonet. The Village Store is on the left, and the Deane and Herbert Store is on the right. (Courtesy Freetown Historical Society.)

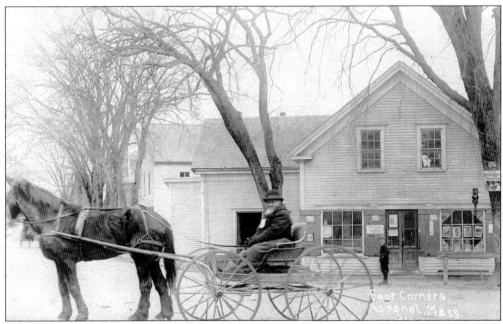

In the background at Assonet Four Corners is Peabody's Store. The store was run for many years by John W. Peabody and then by Charles P. Terry. The store was later owned by James McCauley, and at one time it was the office of the *Village Voice* newspaper. In the wagon is Anthony Hathaway, who was superintendent of Fall River Granite Company. (Courtesy Bob Dorsey, Winter Hill Antiques.)

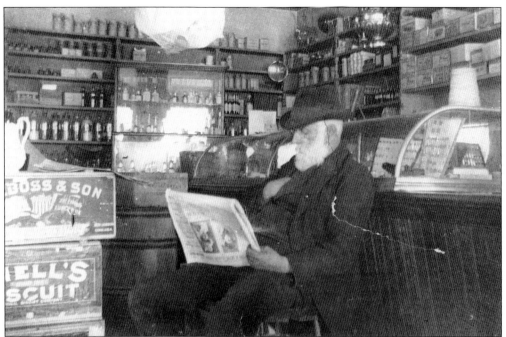

Capt. John Marble is enjoying a newspaper at Peabody's Store in the late 1800s. Lined up on the shelves are patent medicines that Peabody made. Marble was a ship carpenter and joiner. He served in the Civil War in various campaigns and held various ranks. He was active in town matters, and at one time he was an elected member of the Massachusetts legislature. (Courtesy Freetown Historical Society.)

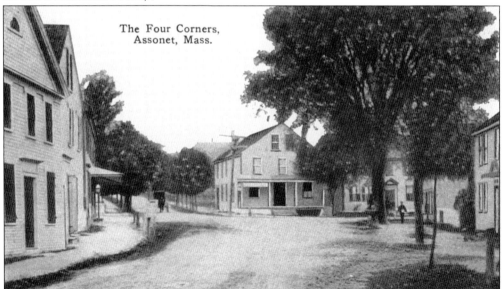

In the 1880s and 1890s, the Village Improvement Society planted trees at Assonet Four Corners. In this view taken about 1900, the town fountain can be seen under the large tree on the right. On the left with the overhang is Pierce's Hall. In the center is the home of Col. Thomas Gilbert, who was a British Revolutionary War officer who was defeated at the Battle of Freetown. (Courtesy Bob Dorsey, Winter Hill Antiques.)

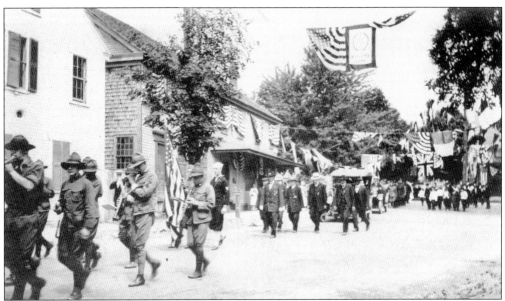

Welcome Home Day following World War I was held on August 12, 1919. The program of the day began with a band concert at 10:00 a.m. A parade, unveiling of the honor roll at Assonet Four Corners, and presentation of medals began at 10:30 a.m. The chairman of the committee for the event was Dr. Charles A. Briggs, with Francis P. Daley as secretary and Eugene A. Herbert as treasurer. A firemen's muster was held on Water Street at 12:15 p.m. A clambake was held at 1:00 p.m. The committeemen for the clambake were Harris E. Chace, Charles P. Terry, and John F. Allen. Other events were listed in the program as community singing, field sports, vaudeville entertainment in town hall, and dancing. (Courtesy Freetown Historical Society.)

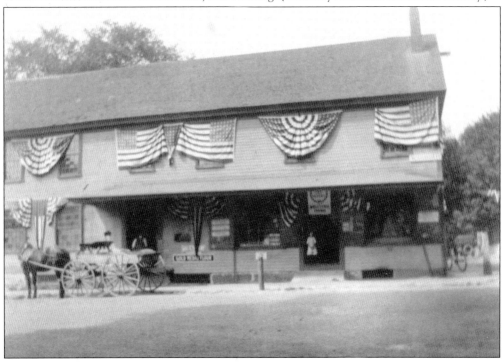

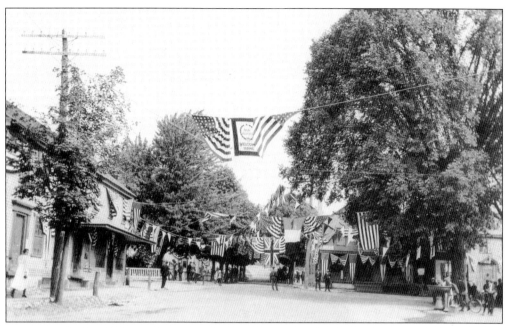

Addresses were given during Welcome Home Day by Rev. John T. Nichols, D.D.; Brig. Gen. Charles E. Cole; and Albert P. Langtry, secretary of state. Stores, churches, and the library went all out with their patriotic decorations for Welcome Home Day. Members of the committee on decorations were Walter H. Cudworth, Joseph S. Strobridge, and Le Roy Chace. The Guilford H. Hathaway Library (pictured below) is located on North Main Street across from town hall. The building, built in 1895, was given to the town by E. Florence Hathaway (Mrs. J. F. Crowell) in memory of her father, Guilford H. Hathaway. The land was donated by John Wilson. The library opened in the fall of 1895. (Courtesy Freetown Historical Society.)

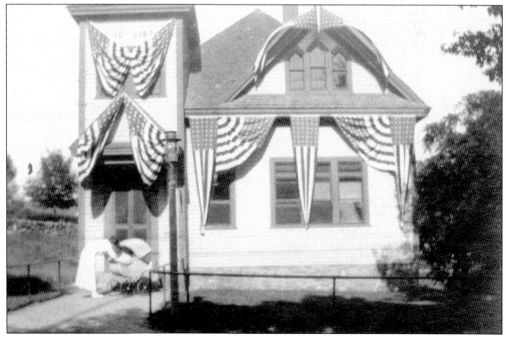

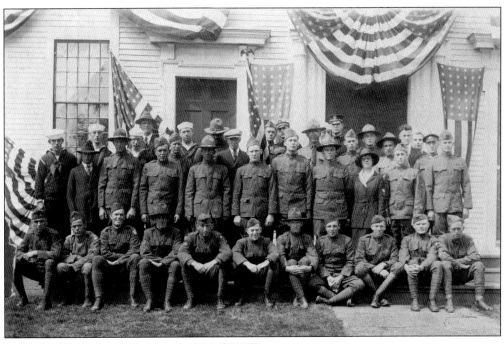

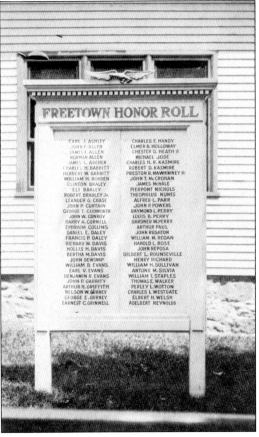

CARL J. ASHLEY	CHARLES F. HANDY
JOHN F. ALLEN	ELMER B. HOLLOWAY
JAMES I. ALLEN	CHESTER D. HEATH ★
NORMAN ALLEN	MICHAEL JOSE
JAMES C. ARCHER	CHARLES H. R. KASMIRE
CHARLES H. BABBITT	ROBERT D. KASMIRE
HERBERT W. BABBITT	PRESTON R. MAWHINNEY ★
WILLIAM H. BORDEN	JOHN T. McCROHAN
CLINTON BRALEY	JAMES McHALE
ELI BRALEY	PIERPONT NICHOLS
ROBERT BRADLEY Jr.	THEOPHILUS NUNES
LEANDER G. CHASE	ALFRED L. PARR
JOHN P. CURTAIN	JOHN P. POWERS
GEORGE T. CUDWORTH	RAYMOND L. PERRY
JOHN W. CONROY	LOUIS B. PERRY
HARRY A. CORNELL	GARDNER W. PERRY
EPHRAIM COLLINS	ARTHUR PAUL
DANIEL E. DALEY	JOHN RUSHTON
FRANCIS P. DALEY	WILLIAM M. REGAN
RICHARD W. DAVIS	HAROLD L. ROSE
HOLLIS H. DAVIS	JOHN REPOSA
BERTHA M. DAVIS	GILBERT L. ROUNSEVILLE
JOHN DEWSNAP	HENRY RICHARD
WILLIAM B. EVANS	WILLIAM H. SULLIVAN
EARL V. EVANS	ANTONE M. SILVIA
BENJAMIN R. EVANS	WILLIAM T. STAPLES
JOHN P. GARRITY	THOMAS E. WALKER
ARTHUR H. GRIFFITH	PERLEY L. WOTTON
NELSON W. GURNEY	CHARLES I. WESTGATE
GEORGE E. GURNEY	ELBERT H. WELSH
EARNEST C. GRINNELL	ADELBERT REYNOLDS

Freetown's World War I honor roll includes Carl Ashley, John Allen, James Allen, Norman Allen, James Archer, Charles Babbitt, Herbert Babbitt, William Borden, Clinton Braley, Eli Braley, Robert Bradley Jr., Leander Chase, John Curtain, George Cudworth, John Conroy, Harry Cornell, Ephraim Collins, Daniel Daley, Francis Daley, Richard Davis, Hollis Davis, Bertha Davis, John Dewsnap, William Evans, Earl Evans, Benjamin Evans, John Garrity, Arthur Griffith, Nelson Gurney, George Gurney, Earnest Grinnell, Charles Handy, Elmer Holloway, Chester Heath, Michael Jose, Charles Kasmire, Robert Kasmire, Preston Mawhinney, John McCrohan, James McHale, Pierpont Nichols, Theophilus Nunes, Alfred Parr, John Powers, Raymond Perry, Louis Perry, Gardner Perry, Arthur Paul, John Rushton, William Regan, Harold Rose, John Reposa, Gilbert Rounseville, Henry Richard, William Sullivan, Antone Silvia, William Staples, Thomas Walker, Perley Wotton, Charles Westgate, Elbert Welsh, and Adelbert Reynolds. Chester Heath and Preston Macwhinney died in war. (Courtesy Freetown Historical Society.)

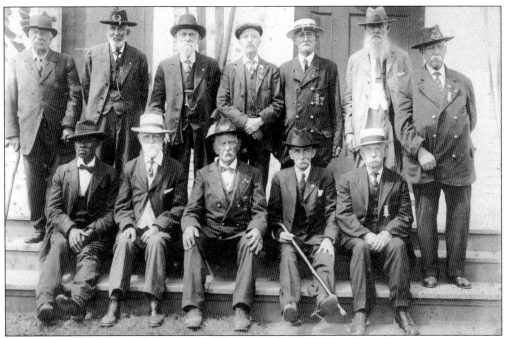

Freetown's Civil War veterans were photographed at the Welcome Home Day festivities. Although there is no record to match the names to the picture, the men in the front row include Robert Thomas, George B. Cudworth, James Herbert, and Frank Bosworth; the men in the back row include J. Lucas, Albert Evans, William Goff, and Nathaniel Pittsley. (Courtesy Freetown Historical Society.)

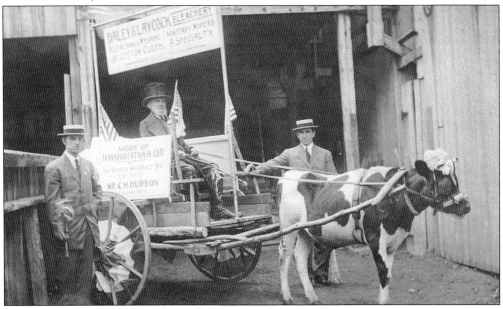

This vehicle was a float in the Welcome Home Day parade and advertises the Daley and Laycock Bleachery in Assonet. It was built by C. H. Hurson, who is the driver in this photograph. The bleachery was located on Mill Street midway between Locust Street and Elm Street. (Courtesy Bob Dorsey, Winter Hill Antiques.)

This postcard is identified as "Boys of Wildwood, East Freetown". Wildwood was a girls' camp. It was located on Mason Road. The camp was owned by the Diocese of Fall River and leased to Margaret Jackson and Elizabeth Ford, who ran the camp. There was also a trout farm there. The trout farm was sold as private property in 1943. (Courtesy Bob Dorsey, Winter Hill Antiques.)

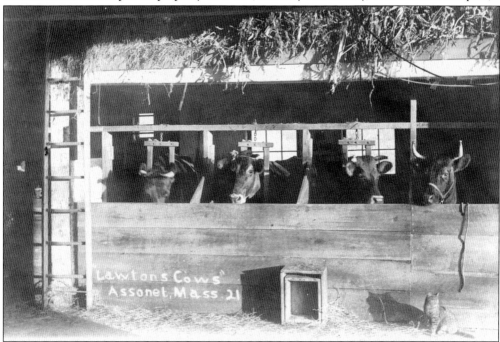

These are Gerard Lawton's cows pictured in Assonet about 1911. He had 10 to 15 cows at his farm on South Main Street. Lawton was a dairy farmer, and he sold his milk commercially. Any farmer who had two or more cows would at times have extra milk that they would sell to local families. (Courtesy Freetown Historical Society.)

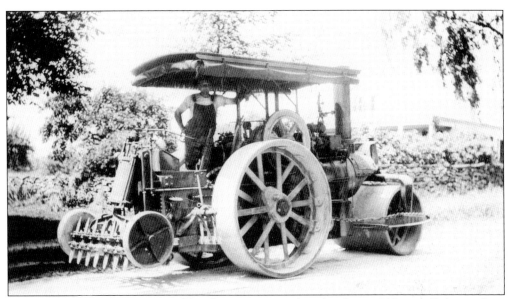

This early steamroller was owned by the town. It was bought about 1930, to roll the roads in order to keep the dust down. It did not go very fast as it was run by steam from a boiler. Roy Chace was the first man to operate it. (Courtesy Freetown Historical Society.)

The farm of Samuel Richmond, built in 1775, was located on Richmond Road. Isaac Richmond and Col. Silas Peirce Richmond later owned the farm. The house was on one side of the road, and the barn was on the other side. Silas was commissioned a colonel in the Civil War and was at both Savannah and Charleston when they were taken. (Courtesy Freetown Historical Society.)

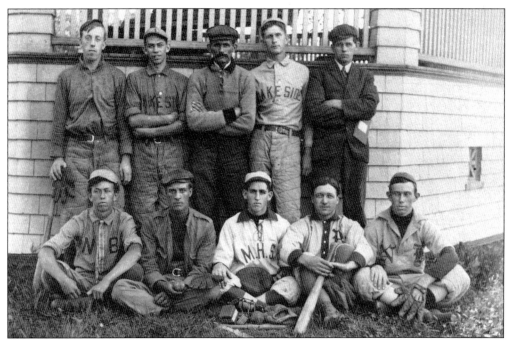

This Lake Side Park baseball team photograph was taken in front of the Lake Side Park Casino on Middleboro Road. The players are, from left to right, (first row) Preston Gurney, Pardon Taber, Edward Drummond, Ted Russell, and Frank Barrows; (second row) Ben Woodsome, Clarence Gurney, Harry Taber, Nate Rounsville, and Louis Gurney. (Courtesy Freetown Historical Society.)

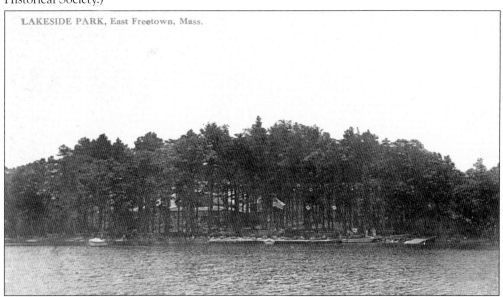

Lake Side Park was started by the streetcar company on Middleboro Road and Long Pond about 1899. The park featured swimming, games, an orchestra, and dancing. The park closed about 1919, when the trolley cars stopped running. During World War II, the site was used by the military. In 1921, Cathedral Camp Chapel was built there and operated by the Diocese of Fall River. (Courtesy Bob Dorsey, Winter Hill Antiques.)

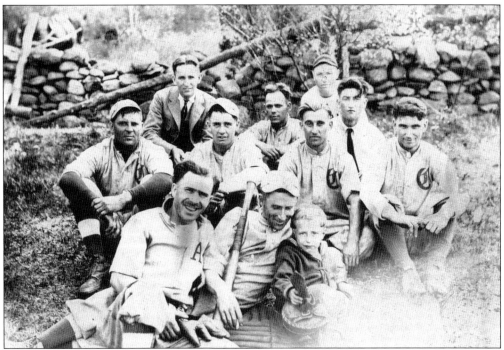

The town periodically had a baseball team that would compete in a league against teams in three or four other area towns. They took baseball very seriously, and local businesses would sponsor the teams. There were also pickup teams until the late 1930s, so that anyone could play. (Courtesy Freetown Historical Society.)

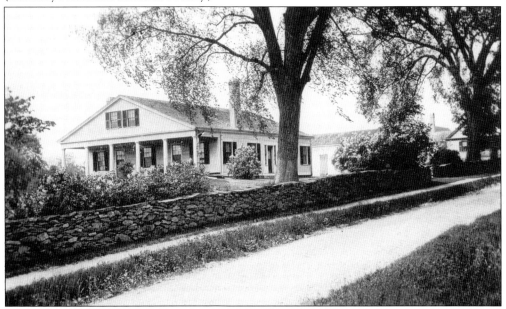

In 1901, the North Congregational Church purchased the Capt. Rufus Bacon home to be used as a parsonage. Bacon was a sea captain. The house had been built about 1814. Located on North Main Street, it was used as a parsonage for only a short time. (Courtesy Freetown Historical Society.)

The New Bedford Water Works was constructed on Little Quittacas Pond in 1866–1869. The pond still supplies water to the city of New Bedford. Before the mid-1900s, anyone could go inside the pumping station. From catwalks, one could view the beautiful brass steam engine. The New Bedford Water Works was built in a landscaped, parklike setting available for public use. (Courtesy Freetown Historical Society.)

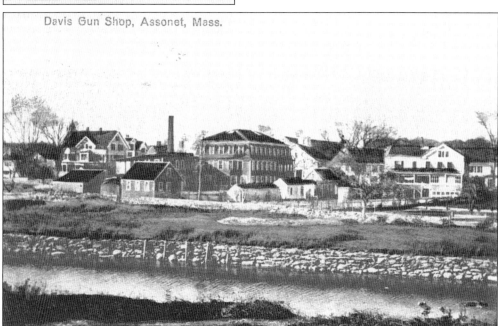

In 1853, N. R. Davis and Company began manufacturing guns in Assonet. Nathan R. Davis and David C. Thresher were the first owners. The business moved several times within Assonet, with the last factory being on Water Street. The sons of Nathan R. Davis later ran the business. The sons sold one-half interest to Warner Arms. Davis Warner Arms closed its Assonet factory after World War I. (Author's collection.)

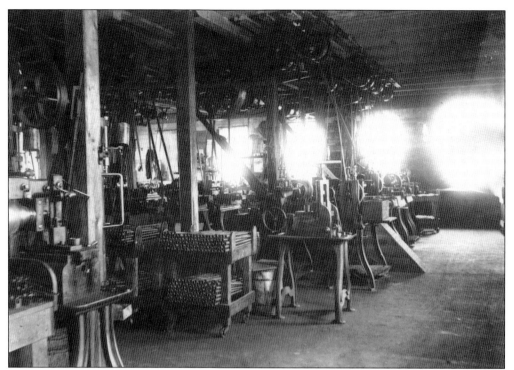

This photograph was taken inside the Davis Gun Factory in the 1890s. In 1916, the factory began making pistols as well as the rifles and shotguns that made the factory known nationally. In 1919, the company moved to Connecticut. A company working with reclaimed mattresses then occupied the building. (Courtesy Freetown Historical Society.)

Melanie Thomas is seen here in July 1946, fishing on Long Pond with her father, Benjamin D. Thomas. He was a school principal in the School Street School in Middleboro and the Berkley Elementary School in Berkley. At the time of this picture, Thomas was principal of Hingham High School. (Courtesy Melanie Dodenhoff.)

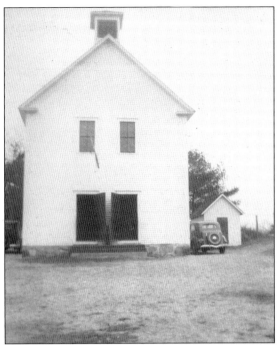

The Braley School was located on Quanapoag Road in East Freetown. The school was officially known as the Union Primary and Grammar School. It was a two-story schoolhouse, built in 1889 by Warren A. Pittsley and Everett W. Lucas. The school housed first through eighth grades. (Courtesy Freetown Historical Society.)

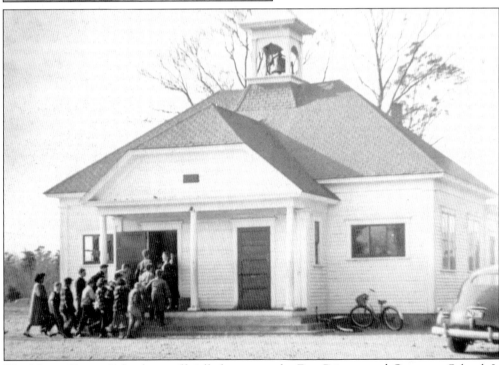

The Mason Corner School was officially known as the East Primary and Grammar School. It was located at Middleboro and Mason Roads. The addition to the school was built in 1911 by Abial S. Ashley. Today it is the Veterans of Foreign Wars hall, and the bell is now on a replica of the Mason Corner School, which was built at the Freetown Historical Society. (Courtesy Freetown Historical Society.)

Furnace School was built in 1862, on Chace Road near the corner of Braley Road. About the late 1930s, it was the site of clambakes put on for several years by the fire department. From the 1920s until 1950, only grades 1 through 4 attended this school. The school closed in 1950. It was remodeled to be used as a home. (Courtesy Freetown Historical Society.)

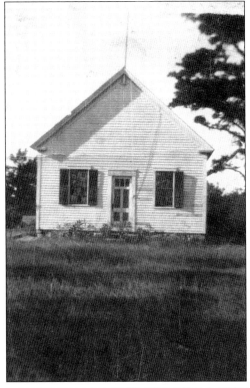

On September 11, 1950, the Freetown Elementary School was opened. At that time, all the village schools were closed, and all Freetown elementary students went to this school. The teacher pictured in this classroom is Gladys Terry. She was a teacher in the Freetown school system for many years. Her first teaching position in Freetown was at the Chace School. (Courtesy Freetown Historical Society.)

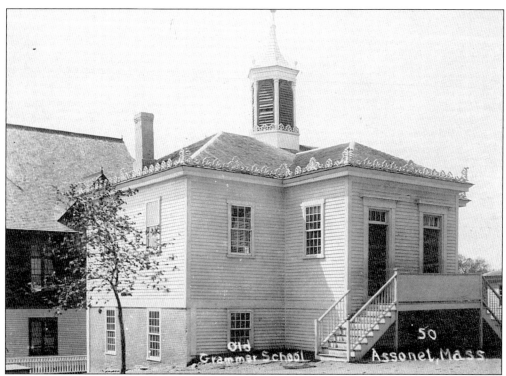

The town house was built in 1809, as a lawyer's office. Later one room was used by the town, and a school occupied a second room. The building was sold to Benjamin Chase Jr., who used it as a private academy. It was again used as a schoolhouse about 1860. The Village School closed after the Freetown Elementary School opened. (Courtesy Bob Dorsey, Winter Hill Antiques.)

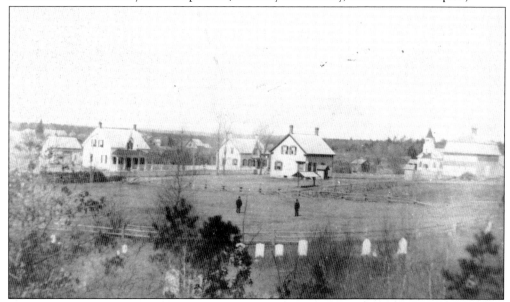

This is a view from the Rounsevill Cemetery in East Freetown, looking toward County Road, as it was seen in the mid-1870s. To the far right of the picture is the stable of an early stagecoach stop. The houses in this view are still standing. (Courtesy Freetown Historical Society.)

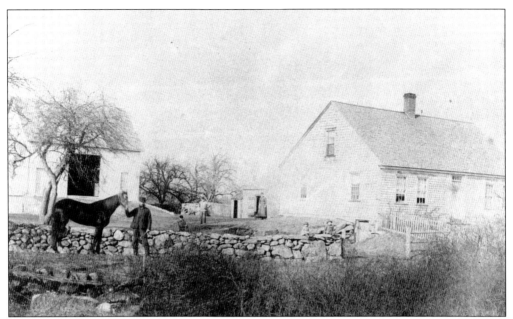

Eugene Kendrick is pictured here in the foreground at his farm on Dr. Braley Road in East Freetown around 1920. East Freetown, or New Freetown as it was also known, was a part of Tiverton and was annexed to Freetown in 1747. The East Freetown part of town encompasses part of Long Pond and borders on Little Quittacas Pond. (Courtesy Freetown Historical Society.)

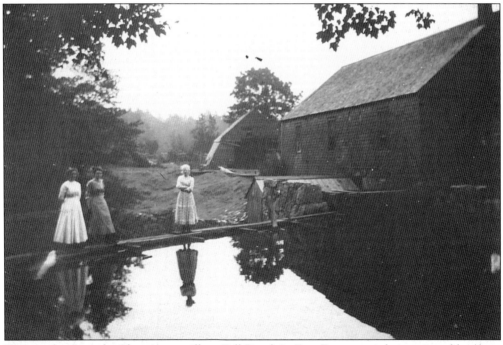

The pond at Lincoln Chace's sawmill on Fall Brook in East Freetown is being viewed by (from left to right) Sarah Imogene Braley, Ella Braley, and Ruth Gurney about 1910. Mill Pond is a man-made pond on Fall Brook. The pond was further enlarged in 1956 and in 1960. (Courtesy Melanie Dodenhoff.)

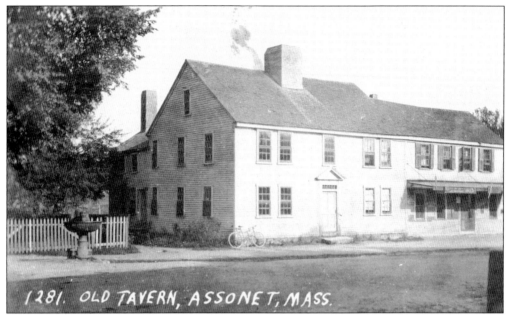

1281. OLD TAVERN, ASSONET, MASS.

The Old Tavern and town fountain were located at Assonet Four Corners. The fountain was installed in 1892 by the Village Improvement Society. The fountain was rusting, and it was removed about 1940. It was stored behind the town hall, and then it was donated to the scrap iron drive during World War II. (Courtesy Freetown Historical Society.)

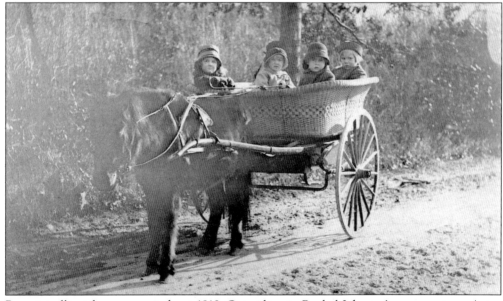

Brew is pulling the pony cart about 1919. Out riding in Rachel Johnson's pony cart are Anna Kirker, Jenette Bentley, James Kirker, and Lynwood H. French. Lynwood H. French was the first president of the Freetown Historical Society, which was organized in 1968, and he continues in that position today. (Courtesy Freetown Historical Society.)

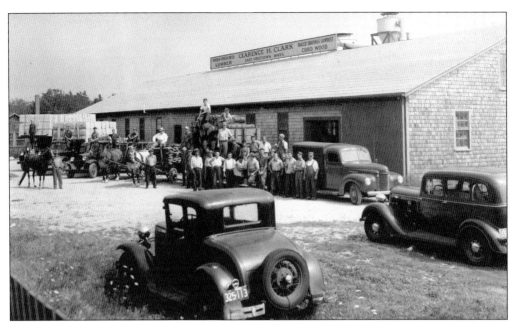

On January 13, 1935, Clarence H. Clark started his lumber company. The sign states in addition to manufacturing boxes he sold cordwood, lumber, and shavings. Pictured here at his mill are his employees. On August 7, 1945, the company was sold to the Freetown Box Company. The last day of sawing logs here was July 14, 1959. The mill was torn down in October 1963. (Courtesy Freetown Historical Society.)

John Durfee Wilson and his wife, Betsey P., are pictured here. In 1850, Wilson owned a sawmill and gristmill on the Assonet River with Job Pierce. Wilson later bought out Pierce. Betsey died in 1896, and John died in 1901, at the age of 86 years. (Courtesy Freetown Historical Society.)

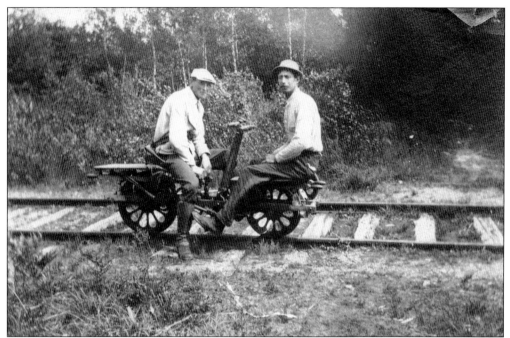

Dwight Heath (right) and Will Barnes are shown on a handcar, working on the pipeline in 1917. The pipeline was a siding from the railroad to the New Bedford Water Works. It ran over the New Bedford Water Works right-of-way. The siding was used to carry the laborers and deliver the coal to the New Bedford Water Works. (Courtesy Freetown Historical Society.)

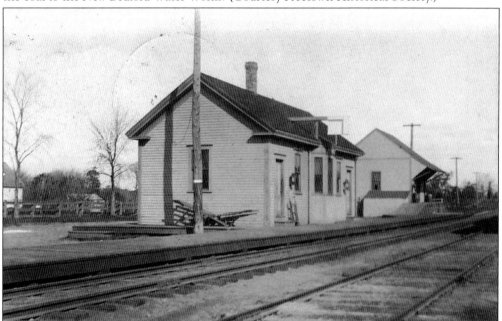

The Assonet railroad depot and freight house were built in the late 1840s, on Slab Bridge Road. George Wing was the stationmaster, and David Terry was the last freight agent. There were quite a few sidings here so they could unload coal and grain, which were no longer being delivered to the wharves on the Assonet River. (Courtesy Bob Dorsey, Winter Hill Antiques.)

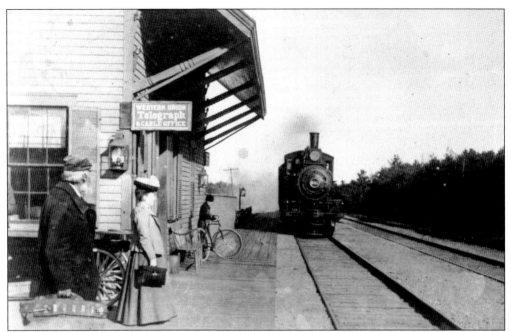

Ed Braley, mail carrier, and Bessie Chace are shown at the East Freetown railroad station. The station was built in the late 1840s. This is a picture of a steam engine coming into the station. The station was on the north side of Chace Road, and the storage shed was on the south side of the road. (Courtesy Freetown Historical Society.)

Herbert F. Gurney (left) and a friend are seen here cutting ice. The ice-cutting machine replaced cutting the ice by hand with a saw. There were several icehouses in town. The icehouses usually burned down because of the heat that would build up in the sawdust that was used to insulate the ice. (Courtesy Freetown Historical Society.)

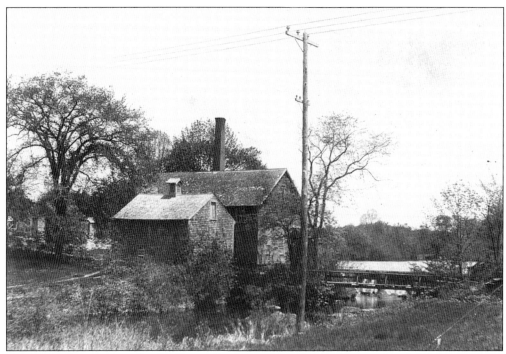

This is the former sawmill of J. Henry Peirce at Forge Dam, off Forge Road. The picture was taken about 1905. Before Peirce's sawmill, this was a shingle mill, further back a cut nail mill, and originally a gristmill operated by the Hathaway family. (Courtesy Bob Dorsey, Winter Hill Antiques.)

The Assonet Brass Band is pictured here in the 1880s. In the early 1930s, the Boy Scouts had a band and built a bandstand behind Charles Terry's store. Terry let the band run an extension cord from his store so they could have lights. The bandstand was later moved and incorporated into the bandstand that was built by the Work Progress Administration. It is located near Assonet Four Corners. (Courtesy Freetown Historical Society.)

Three

LAKEVILLE

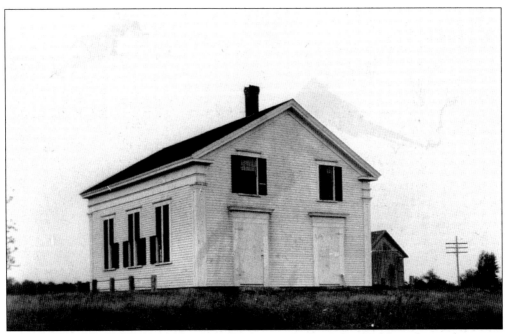

The Lakeville Town Hall (Lakeville Town House) was built on the Washburn lot on the corner of Precinct Street and Bedford Street. Town meetings were held here, and the town offices were in the rooms upstairs. From 1908 to 1912, the Lakeville Town House was used as a school for grades one through three. In more recent years, it has been used for club activities. (Courtesy Lakeville Historical Society.)

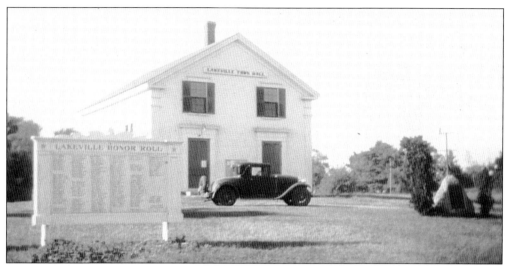

This park in front of the Lakeville Town House was named in honor of Dickran Diran, the only man from Lakeville to die in World War I. At the right is a boulder with a bronze tablet that lists the honor roll from World War I. At the left is a memorial listing of the men and women who served in the armed services during World War II. (Courtesy Lakeville Historical Society.)

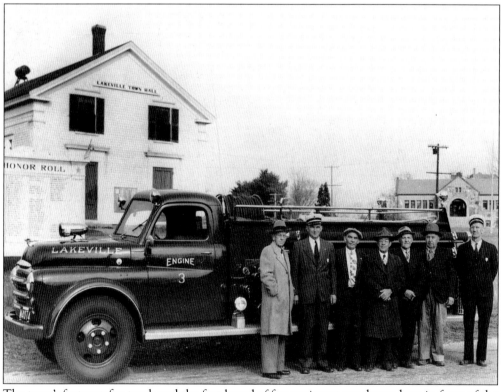

The town's first new fire truck and the first board of fire engineers are shown here in front of the Lakeville Town House. Pictured here are, from left to right, Walter A. D. Clark, Chief Edmund Knysinski, Harold Hemmingson, Edward De Mello, Joseph Gladu, Frank T. Orrall, and Deputy Chief Charles Weston. (Courtesy Lakeville Historical Society.)

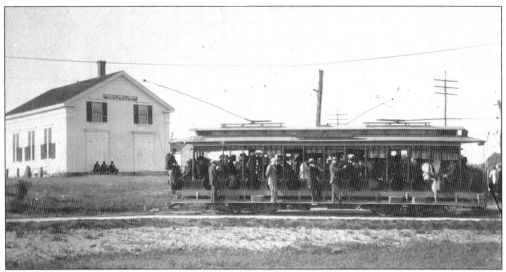

A trolley car, also known as an electric car, full of passengers was photographed in front of the Lakeville Town House. The sign on the side of the car reads "Bridgewater & Middleboro." The first trolley ran in Lakeville in 1899. At the time this picture was taken, the Lakeville Town House was also being used as the public library. (Courtesy Lakeville Historical Society.)

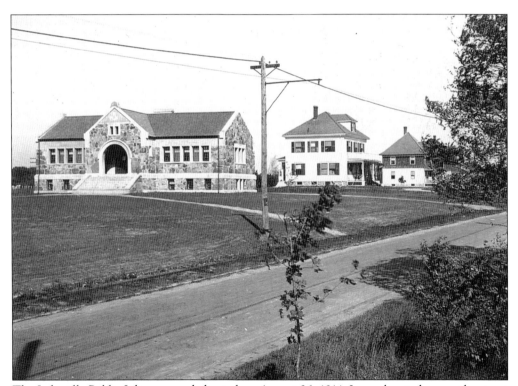

The Lakeville Public Library was dedicated on August 26, 1914. It was located across the street from the Lakeville Town House. The Sewing Circle raised money to help build the library through various events such as dances, lawn parties, luncheons, and suppers. In 1914, there were 2,281 books in the library. (Courtesy Lakeville Historical Society.)

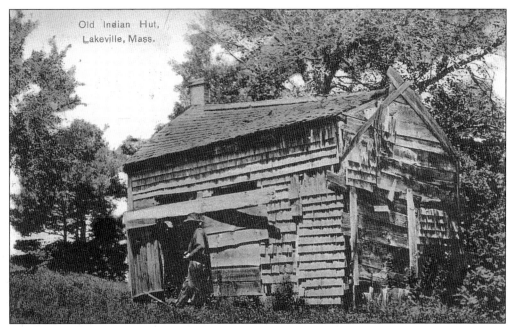

The home of Lydia Tuspaquin, great-great-granddaughter of Massasoit, was located at Betty's Neck on Lake Assawompset. Her great-grandson Alonzo Mitchell was photographed here in the early 1900s. Lake Assawompset, the largest natural body of freshwater in the state at 2,220 acres, was where John Sassamon, a Native American, was found murdered under the ice in 1675. His murder was one event that led up to the King Philip's War. (Author's collection.)

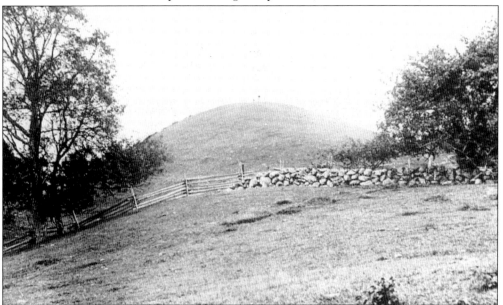

King Philip's Lookout, on Shockley Hill, overlooked Lake Assawompset. It was believed to be where King Philip and his braves watched what was happening around them. It was also used for signaling at night via fires. It is said that from this spot witnesses saw the body of Sassamon being placed under the ice. The hill was leveled in August 1971 and was developed for housing. (Courtesy Lakeville Historical Society.)

When looking from the top of King Philip's Lookout toward Lake Assawompset, Sampson's Tavern, located at the corner of Bedford Street and Highland Road, is seen in the center of the view. This was a stage stop and one of several taverns in town that catered to the travelers from Boston as well as to those who summered on Lakeville's numerous lakes and ponds. (Courtesy Lakeville Historical Society.)

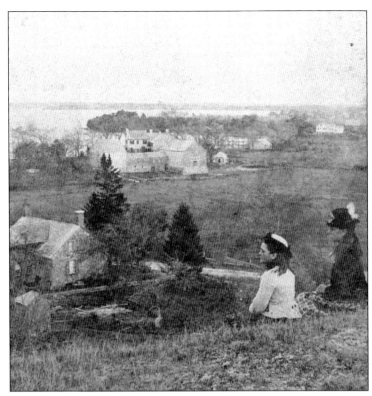

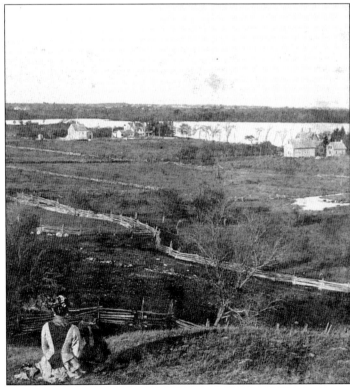

This is a view of Lake Assawompset that shows the former Cook residence, which later became the Linden Lodge. Harold C. and Dorothy S. Grover were the owners of the lodge, located on Bedford Street. Clarence J. Grover was the cook. Linden Lodge was torn down, and a shopping plaza was built at the site. (Courtesy Lakeville Historical Society.)

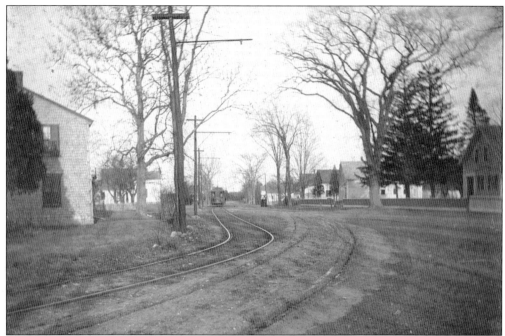

The first trolley ran in Lakeville on Labor Day 1899, and the last trolley ran exactly 20 years later, on Labor Day 1919. At various times it ran under three different street railway companies, Old Colony, Bay State, and Eastern Massachusetts. Here a car is shown in front of the Precinct Church as it travels from South Precinct Street through Precinct Village. (Courtesy Lakeville Historical Society.)

Trolley car men stationed in Lakeville were photographed on September 17, 1922. Among the men who served in Lakeville at various times as motormen, conductors, and superintendents on the line were Walter Cornell, Albert Harrison, John Hayes, Alfred P. Manton, Bertram Manton, A. C. Ralph, and George Smith. (Courtesy Lakeville Historical Society.)

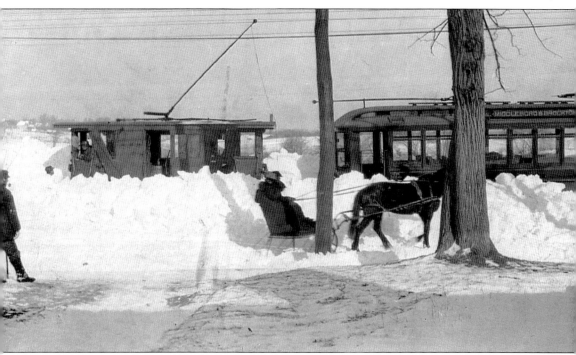

The "Lake Shore Road" line of the New Bedford, Middleboro, and Brockton Street Railway ran from Lund's Corner in New Bedford to Brockton. The Lakeville schedule was twice an hour in the summer months, and in the winter months, it ran once every hour. A short line ran from the Lakeville Town House to East Taunton. This picture was taken on January 16, 1910. The trolley car barn was located on Lakeside Avenue. The brick barn located near Plymouth Street had eight tracks with a generator station for powering the electric lines. The barn was torn down in 1935. The line received its nickname of "Lake Shore Road" because it ran along Long Pond and Lake Assawompset. (Courtesy Lakeville Historical Society.)

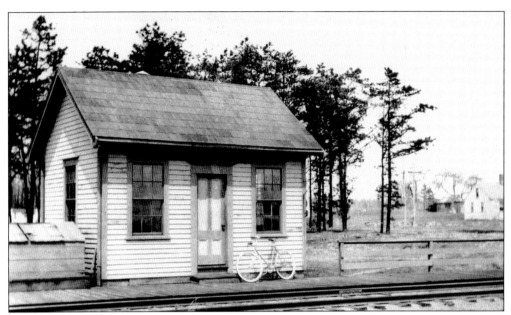

The New York, New Haven, and Hartford Railroad operated several lines in southeastern Massachusetts. The North Lakeville railroad station, shown above, was one of four railroad stations located in Lakeville. The North Lakeville railroad station and the Turnpike Station were on the Taunton and Middleborough branch of the line. Howlands Station, on Howland Road, was on the Taunton and New Bedford branch of the line. Lakeville Station, shown below in 1896, was located on Bedford Street, and it was on the Middleborough and Fall River branch of the line. The Lakeville Station shown on the left side of the photograph is still standing today. (Courtesy Lakeville Historical Society.)

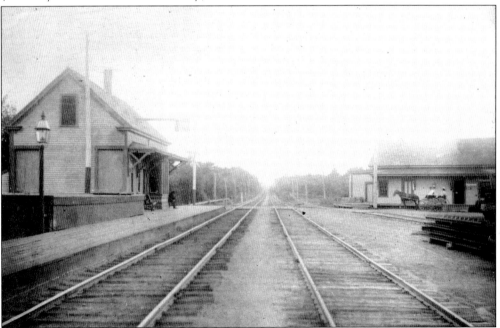

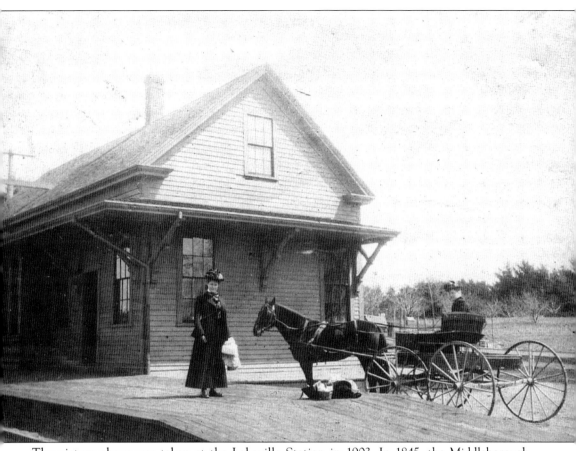

The picture above was taken at the Lakeville Station in 1903. In 1845, the Middleborough Railroad Corporation was chartered. This corporation was authorized to build a railroad line from Middleborough that would connect to the Fall River line in Myricks. Passengers from Lakeville Station could switch trains at Myricks to reach Howlands Station. When the line opened on December 31, 1846, the tracks ran all the way from Braintree to Fall River. Trains ran these rails until 1931, when service was discontinued, and the Lakeville Station was closed. The tracks were pulled up in 1934. (Courtesy Lakeville Historical Society.)

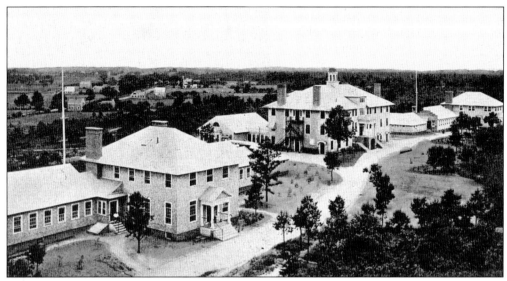

The Lakeville State Sanitarium was opened in 1910, by the State of Massachusetts, as a tuberculosis hospital. It was built at the site of the Doggett farm. Dr. Sumner Coolidge was its first superintendent. Numerous buildings were built as the focus of care changed over the years. The hospital was a major employer in the town. (Author's collection.)

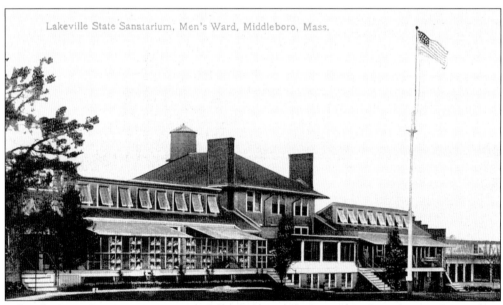

Lakeville State Sanitarium was opened for the care of pulmonary tuberculosis patients. Later crippled children and patients with cerebral palsy and arthritis were admitted. Beginning in 1953, muscular dystrophy patients were also treated here. A school, teaching children up to the eighth grade, was added. Surgery and rehabilitation were provided as well as long-term treatment, but permanent treatment and terminal care were not provided. (Author's collection.)

The staff of Lakeville State Sanitarium thought patient Francis Richard Kalik, "Francis X," would benefit from some cards. A local newspaper article was picked up by the Associated Press and went worldwide. The overwhelming response resulted in rooms full of mail addressed to "Francis X." About 1956, he became the poster boy for Jerry Lewis and muscular dystrophy. Kalik died in November 1966, at age 18. (Courtesy Lakeville Historical Society.)

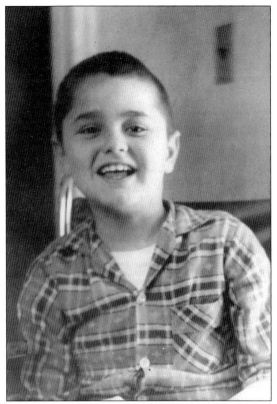

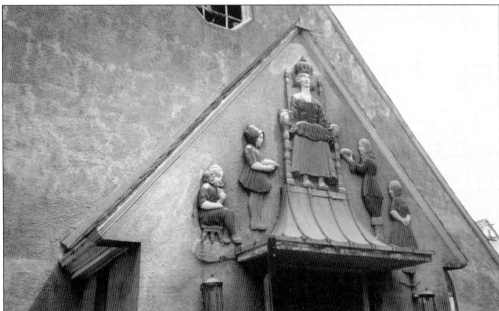

Artwork above the entrance to the children's ward at Lakeville State Sanitarium greeted the children as they approached the building. Depicted are scenes from a nursery rhyme. Kalik was a patient in this ward. The hospital was closed in 1991, due to cost-savings measures taken by the state. (Courtesy Lakeville Historical Society.)

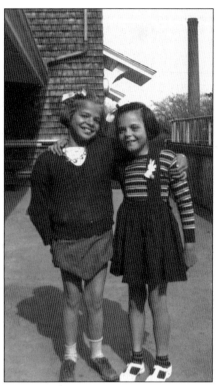

Cynthia Gail Logan (right) and Angelina Angelakis were roommates at Lakeville State Sanitarium. Logan, born in 1933, became a patient when she was a child and remained there for 12 years. She married Evan L. Perkins. She wrote *The Baby's Cross* about her life at the hospital. (Courtesy Lakeville Historical Society.)

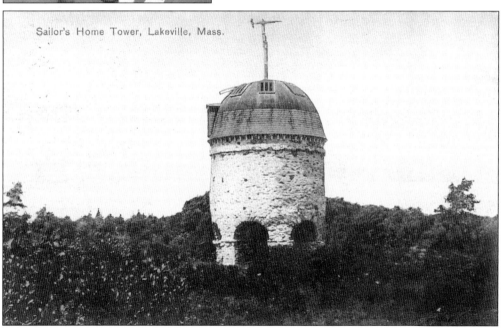

Sailor's Home Tower, Lakeville, Mass.

The Sailor's Tower was built in 1882. It was meant to be a water tower for a home for retired seamen. The project did not get funded. The tower was located off Highland Road. Authors Arthur Hamilton Gibbs and Jeanette Phillips Gibbs wrote books in this tower. He wrote at the top of the tower, and she wrote inside. The tower now belongs to the Lakeville Historical Society. (Author's collection.)

Long Pond is about five miles long and covers 1,760 acres. It was called Lake Apponequet by the Native Americans. It is surrounded by summer and year-round homes. Long Pond is popular for boating as well as swimming. The Long Pond River, sometimes called the Snake River or Assawompset River, connects Long Pond and Lake Assawompset. The regional high school of Lakeville and Freetown is named Apponequet. (Courtesy Lakeville Historical Society.)

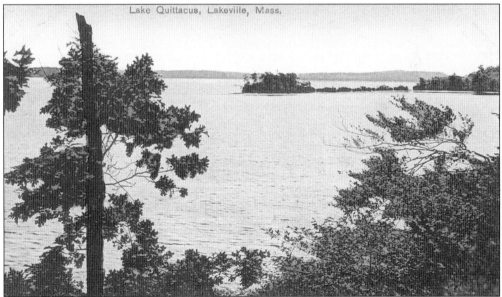

Great Quittacas Pond and Little Quittacas Pond are two of the many bodies of water in the town. They are named for Native American chief Quittacas. Great Quittacas Pond covers 1,128 acres. There are three islands in Great Quittacas Pond. Three towns share these two ponds, Freetown, Lakeville, and Rochester. These two ponds are the source of water for the city of New Bedford. (Author's collection.)

A gatehouse and dam were located at the spot where Lake Assawompset and the Nemasket River met. It was constructed to control the water flow to the pumping station that supplied water to the city of Taunton. It also was used to control the level of water to allow the alewife (herring) to travel the river. The view above shows the building as seen from Lake Assawompset. The gatehouse is pictured below about 1915–1919, with a view taken from the Nemasket River side of the building. The Nemasket River travels from Lakeville through Middleboro to the Taunton River. (Courtesy Lakeville Historical Society.)

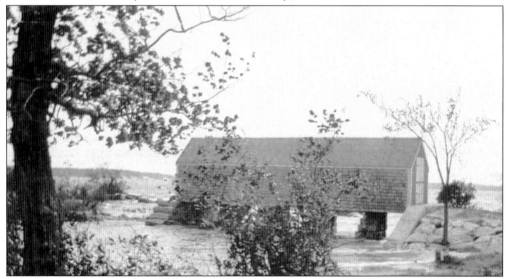

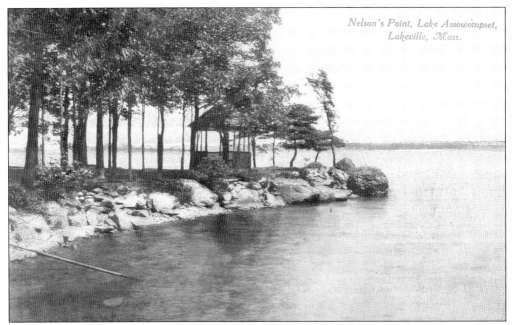

Nelson's Grove is located on Lake Assawompset. *Assawompset* is a Native American name meaning "the place of the white stones." The first summer cottage was built on this lake in 1878, by Joseph Dean of Taunton. Since that time many summer and year-round homes have been built on this beautiful lake. (Author's collection.)

Camping at Nelson's Grove was a popular activity. Nelson's Grove was named for John Hiram Nelson, who built the first of the cottages on this section of Lake Assawompset. Those camping here are, from left to right, Lura Haskell, Edith Perkins, Florence Robinson, and Alonzo Dealtry. This campsite was owned by Lura Haskell and Florence Robinson. (Courtesy Annette Perkins Delano.)

Charles Sherwood Stratton (1838–1883) and his wife, Lavinia (Warren) (1841–1919), had a summer home and boat on Lake Assawompset. They are more commonly known as Tom and Lavinia Thumb. There is a story that Stratton was firing a cannon from his boat in salute to a passing steamboat when the cannon fell overboard, and that the cannon is still in the lake. (Courtesy Lakeville Historical Society.)

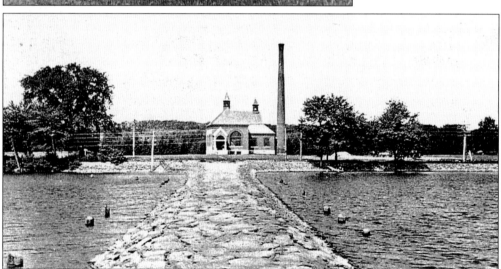

The pumping station was built in 1894. It is pictured here about 1913, as viewed from Lake Assawompset. The station pumped water from the lake to the city of Taunton via Elder's Pond. After the station was no longer needed, the Town of Lakeville bought the building, and today it is used as the town office building. (Courtesy Lakeville Historical Society.)

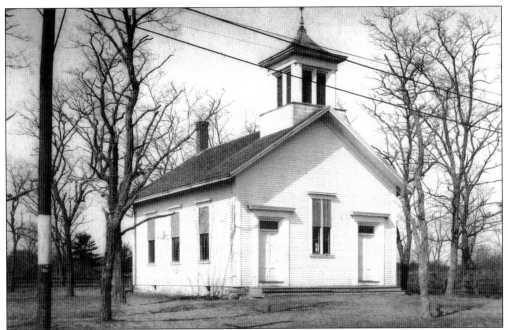

Union Grove Chapel was built on Bedford Street in 1875, on land donated by Sidney Tucker. It later became the Grove Chapel Congregational Church. In 1927, the bell from the Bell Schoolhouse was place in the chapel cupola. The chapel was purchased by Sheldon Vigers for a museum in memory of his mother, Gladys Vigers, and it is now the museum of the Lakeville Historical Society. (Courtesy Lakeville Historical Society.)

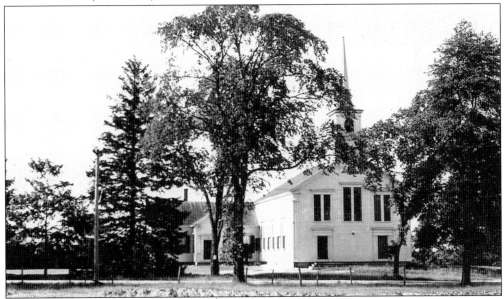

The third Precinct Church building, as pictured here, was constructed in 1835. It was located at Precinct Street and Rhode Island Road. In 1885, a chapel was added to the structure. In April 1970, the building was moved to the site of the former King Philip's Tavern at Bedford and Precinct Streets across from the Lakeville Town House. It is now the Lakeville United Church of Christ. (Courtesy Lakeville Historical Society.)

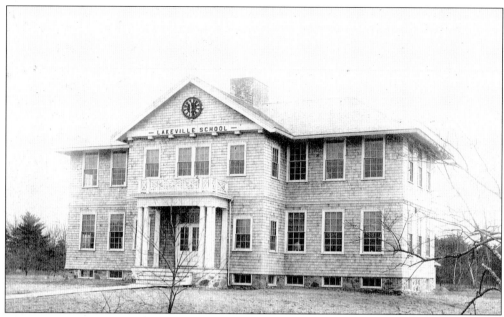

The Assawompset School was built in 1912. The building had four classrooms. When this school opened, almost all of the other district schools closed. The clock on the front of the building was given by Rhoda M. Peirce. An addition of two classrooms and other rooms was built in 1949–1950. Other additions were built including ones in 1955 and 1963. (Courtesy Elizabeth A. Williams.)

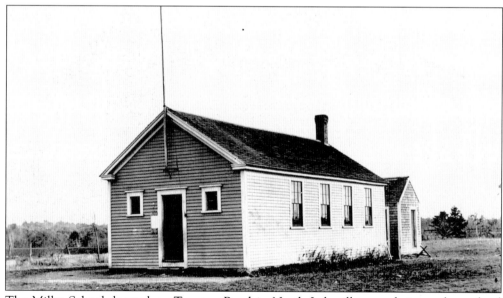

The Miller School, located on Taunton Road in North Lakeville, was designated as school No. 1. After it was no longer used as a school, the building was converted into a house, and it was moved to North Precinct Street. The North Lakeville School was later built on this site. (Courtesy Lakeville Historical Society.)

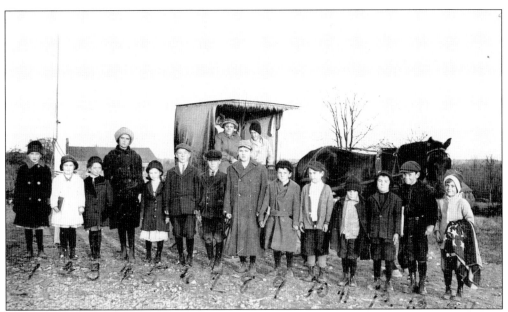

These Parris Hill School children are standing in front of their "school truck." Notice the child on the right is holding a folded United States flag. Among the children are Mary Williams, Ora Bissonnette, Olive Williams, Dorothy Williams, Norman Hoard, and Ulysses Bissonnette. The other children are unidentified. (Courtesy Elizabeth A. Williams.)

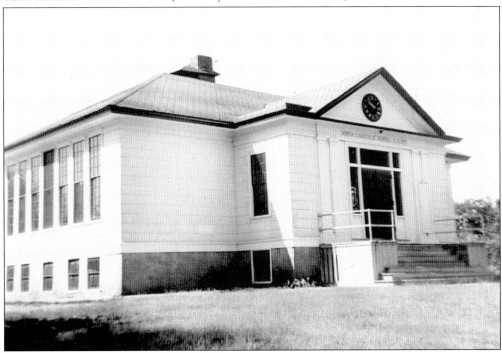

The North Lakeville School was built in 1915 to replace the Miller School. The town had appropriated $5,000 for the building of the school. It was a two-room schoolhouse with each room large enough to accommodate 40 students. It was located on Taunton Road. The first teacher was Effie D. Tucker. (Courtesy Lakeville Historical Society.)

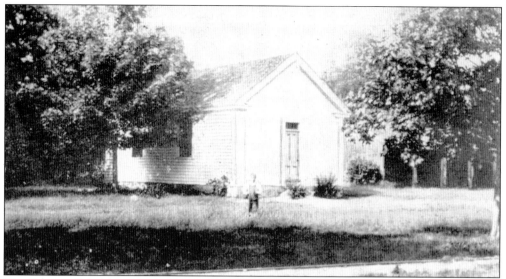

The Precinct School was located in Precinct Village on Pickens Street. It was originally school No. 12 but was renumbered No. 11 in 1855, and then in 1880, it was renumbered again as school No. 10. In 1912, after the Assawompset School opened, the Precinct School closed. (Courtesy Lakeville Historical Society.)

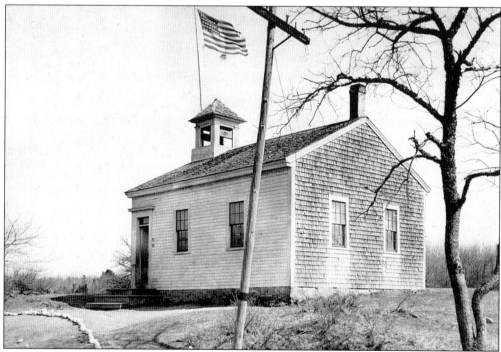

The Neck School, No. 5, was built in 1796. The school was also known as the Bell School because it had a bell, and bells were scarce in those days. The school was located near the turnpike at the area known as Assawompset Neck. The school closed about 1912. (Courtesy Lakeville Historical Society.)

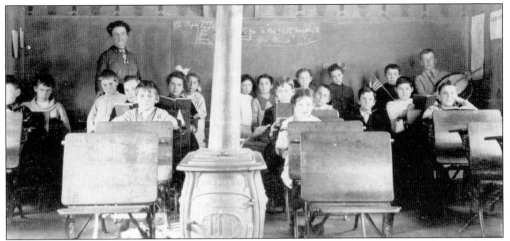

Parris Hill School, on School Street, was open about 1888 to 1924. Pictured are, from left to right, (first row) Guy Pittsley, James Larner, Ronald Hoyle, George Eaton, Mary Williams, Henry Hotten, Ernest Hayes, Leon Hayes, and Alphonse Remy; (second row) Winfred Remy, Harry Chace, Teacher Eunice Pierce, Lizzie Claffin, Olive Williams, Dorothy Williams, Ora Bissonnette, Alice Eaton, Hazel David, Ulysses Bissonnette, and Norman F. Hoard. (Courtesy Elizabeth A. Williams.)

The 1957–1958 North Lakeville School first grade is pictured here. From left to right are (first row) Harry Pierce; (second row) Rita Marshall, Maureen Santos, Mary Ann Sena, Kay Yandell, and Nancy Mann; (third row) Michael Garafalo, Susan Johnson, Patricia Dwyer, Christine Thomas, and Bruce Griswold; (fourth row) Edward Zilinsky, Roy Caliri, teacher Madeline Shaw, Robert Erickson, and Robert Hoard. (Courtesy Lakeville Historical Society.)

The 1963–1964 faculty members of all the Lakeville schools are pictured here. From left to right are (first row) Gail Zeba, Cecile Lindell, Marjorie Cleverty, Sally MacLean, Maureen Baird, Phillis Chase, unidentified, Marie Begley, Eunice Sherman, Madeline Shaw, Cherida Gangone, and Mearl Tribou; (second row) Mildred Badger, unidentified, Margery Washburn, Irving Waitz, Paul Sopa, unidentified, Miriam Edwards, and Joan Tripp. (Courtesy Lakeville Historical Society.)

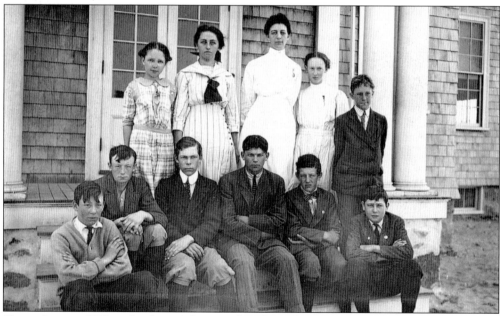

Shown here in 1913 is the first graduating class from the Assawompset School. Pictured are, from left to right, (first row) Russell Haskins, Russell Norris, Richard Bowen, Blake Norris, Howard Ward, and David Ashley; (second row) Verna Mosher, Edna Taylor, Elizabeth Benson, Mildred Ashley, and George Carr. (Courtesy Lakeville Historical Society.)

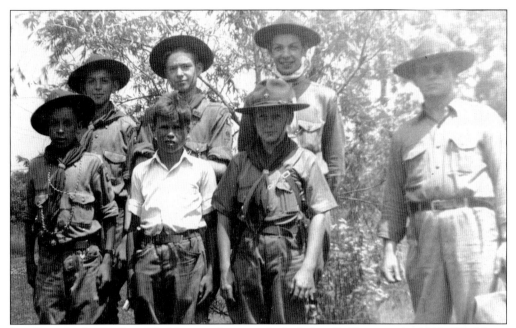

Boy Scout leader Wallace Washburn is shown with the Lakeville Troop in the 1940s. Washburn was an engineer and ran a steam engine at a plant in Bridgewater. He was a noted horseshoe player. Playing horseshoes was a favorite pastime in the 1930s. He participated in horseshoe competitions with players from surrounding towns. (Courtesy Lakeville Historical Society.)

These Girl Scouts in the early 1940s are, from left to right, (first row) Elizabeth MacNeill, Lillian Corayer, and Jean Staples; (second row) Santa and Patricia Haskins; (third row) Josephine Scanlon, Evelyn Banta, and Gloria Tripp; (fourth row, sitting) Anita Goodhue, Janet Washburn, Madeline Turner, Bette Vigers, and Virginia Turner; (fifth row, standing) Evelyn Dwyer, Verna Harris, Bette Erwin, Zelda Atwood, Virginia Norris, and Ann Hemmingson. (Courtesy Lakeville Historical Society.)

The Cub Scouts are pictured here at the Duxbury Monument. They are, from left to right, (first row) Ronald Mello, Merle Washburn, Armand Bolieau, Wayne Griffith, Robert Staples, Ronald Brule, Herbert Breault, and Nelson Staples; (second row) George Orrall, Robert Norris, Arthur Able, Russell Caldwell, James Orrall, Melvin Mastera, Curtis Dow, Jack Gilberti, and Ronald Bissonnette. (Courtesy Lakeville Historical Society.)

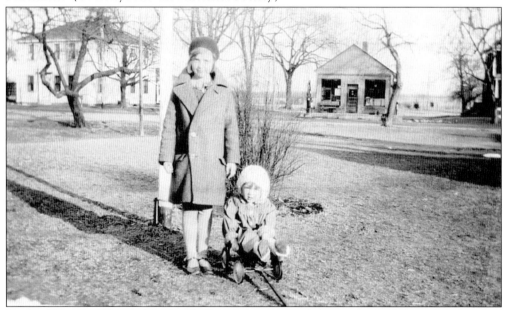

Pictured here in 1930 are Martha (left) and Annette Perkins. In the background is the P. G. Higgins Store. This general store was bought in 1942 by Frank Mello. The store was located at the corner of Vaughan Street (behind Martha) and Main Street. The corner was known as Upper Four Corners. The house on the left was moved when Route 105 was widened. (Courtesy Annette Perkins Delano.)

Gladys Vigers wrote *History of the Town of Lakeville Massachusetts*. It took her about seven years to write the book. The town took it on as a project with a town committee editing the book, funding it, and publishing it in time for the town's centennial in 1953. Gladys's son Sheldon was the first president of the Lakeville Historical Society. (Courtesy Lakeville Historical Society.)

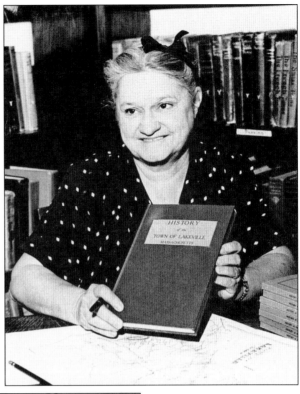

Martin King Staples of County Road is presented the Boston Post Cane by selectman Henry Pember on March 20, 1948. Selectman Wallace Wilkie (left) and C. Ashley are also present to honor Staples as the oldest resident of the town of Lakeville. The gold-headed cane was presented to the town by the Boston Post to be given to the town's oldest resident. (Courtesy Lakeville Historical Society.)

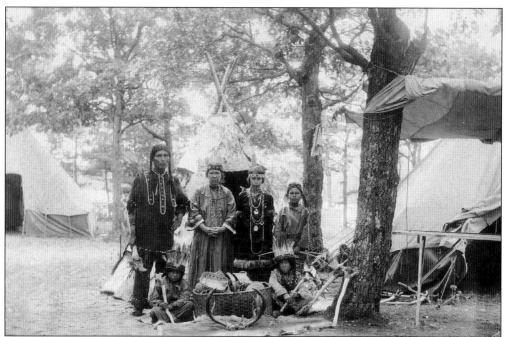

The Horace Nicholas family, Narragansett Indians from Kingston, Rhode Island, is seen here at their campsite on Betty's Neck about 1910. Betty's Neck, on the southern shore of Lake Assawompset, was called Nahteawamet by the Wampanoag Indians who lived there before the landing of the *Mayflower*. The Native Americans who lived there were devastated by disease in 1617. (Courtesy Lakeville Historical Society.)

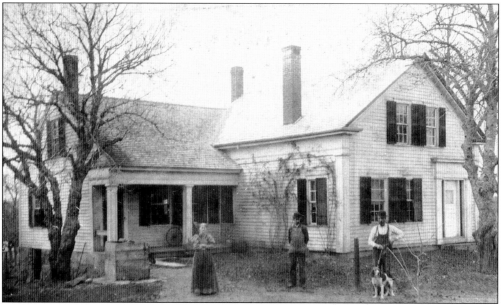

Alton Hoard, his wife, and one of his brothers are shown at Hoard's house on Pierce Avenue around 1890. His descendants are the current owners of this house. Pierce Avenue was formerly known as Beechwoods Road and the Carroll Pit Road. Several granite quarries were located along this section of Pierce Avenue. (Courtesy Elizabeth A. Williams.)

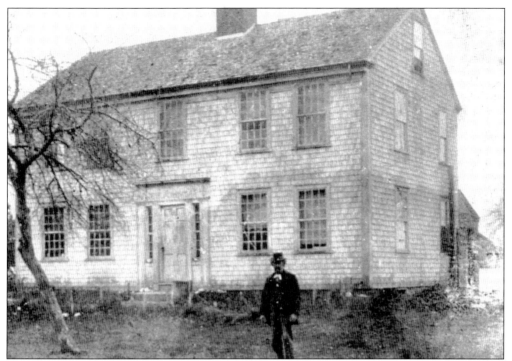

This house on Pierce Avenue was owned by Jirah Winslow and later by the Chester Peirce family. It is pictured here in 1896. For many years, one end of the street was Pierce Avenue, and the other end was Peirce Avenue in recognition of the two branches of the family and the varying spelling of the family name. (Courtesy Lakeville Historical Society.)

The Strobridge house on Kingman Street is located by Holloway Brook. William Strobridge, a blacksmith, built this pre–Revolutionary War gambrel cape home in the very early 1700s. The windows are located near the roofline. By 1879, the home was purchased by the Williams family, which has maintained ownership through the present time. Holloway Brook joins Cedar Swamp River, which empties into the Assonet River. (Courtesy Elizabeth A. Williams.)

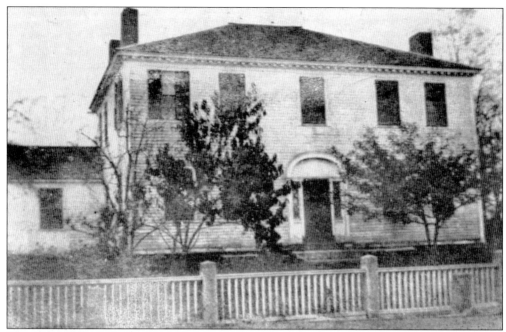

The House of Seven Chimneys was located on Pickens Street at the corner of Hill Street. The last owner of this unusual house was Benjamin Pickens. This beautiful house was completely destroyed by fire on February 8, 1920. Pickens tragically lost his life in that fire. (Courtesy Lakeville Historical Society.)

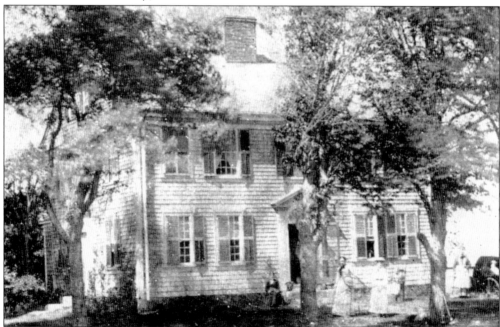

The Oliver Peirce homestead on Pierce Avenue was built about 1810. It was owned in the 1900s by Percival F. Staples and is still a residence today. Pierce Avenue in its earliest days was known as Beechwoods Road. It was named for a type of tree that was prevalent in this part of town. (Courtesy Lakeville Historical Society.)

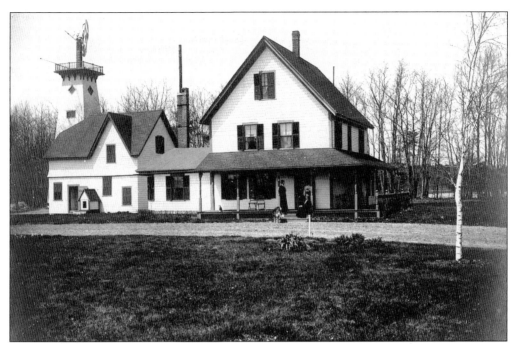

The home of Orville K. Gerrish was built about 1889. It was located on Loon Pond and later moved to Precinct Street. In the early 1920s, it was sold to the Boston Council of Boy Scouts for a summer camp. The Ted Williams Camp was located here after the Boston Council of Boy Scouts sold the property. (Courtesy Lakeville Historical Society.)

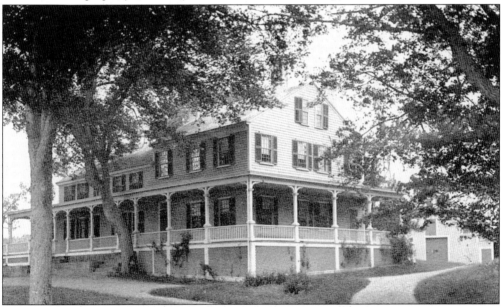

Sampson's Tavern, formerly Foster's Tavern, opened in 1798. This tavern was located on Bedford Street, formerly the Old Turnpike. It provided food and shelter to travelers on the Boston to New Bedford stagecoach line. The two dining rooms could seat up to 100, and dancing was popular at the tavern. It was sold to the City of Taunton in 1911, and the buildings were removed. (Courtesy Elizabeth A. Williams.)

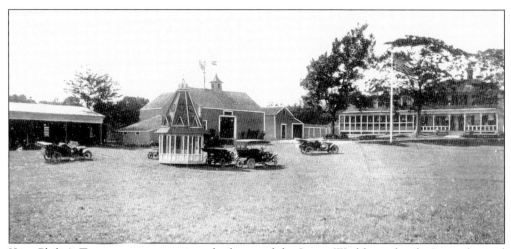

King Philip's Tavern was at one time the home of the James Washburn family. It was located at the intersection of the roads from Taunton, Middleboro, New Bedford, and Boston. It became the King Philip's Tavern after it was sold by the Washburn family. It was one of several taverns and inns in town that catered to travelers and the summer tourists. (Courtesy Lakeville Historical Society.)

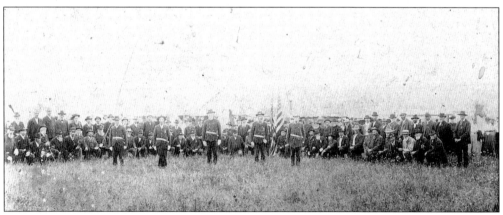

During the Civil War, an encampment for the volunteer militia was established in Lakeville. The camp on Staples Shore Road was named for Gen. Joseph Hooker and was known as Camp Joe Hooker. It was comprised of three leased farms, and each farm was occupied by one of the three regiments, the 3rd, 4th, and 5th. This camp was used for training up until 1914. (Courtesy Lakeville Historical Society.)

CAMP JOE HOOKER, LAKEVILLE, MASS., 1914

This 1914 encampment, or muster, was one of several held over the years at Camp Joe Hooker. The weeklong sessions were used for training servicemen. One year, the entire 2nd Brigade from Framingham trained here on the shores of Lake Assawompset. The 2nd Brigade consisted of the 5th, 8th, and 9th Regiments, Troops A and D of the cavalry, and Light Battery A. (Author's collection.)

The King Philip's Tavern was used as the headquarters of Officers and Umpires in the Great War Games that were held August 14–21, 1909. These games were held in Lakeville until 1914. The King Philip's Tavern burned in April 1918. Today it is the site of the Lakeville United Church of Christ. Some of the original posts in front of King Philip's Tavern are still there today. (Author's collection.)

Shown in the picture above is an encampment as tents are being set up at Camp Joe Hooker. Guns are neatly stacked next to the tents. The German 17-millimeter cannon shown below was presented to the Town of Lakeville by the Republic of France after World War I. Henry L. Pember, who was the chairman of the Welcome Home Committee, presented the cannon to the town at ceremonies held on May 30, 1920. The cannon was accepted by selectman Alton Hoard. The cannon was donated to the scrap metal drive that was held during World War II. (Courtesy Lakeville Historical Society.)

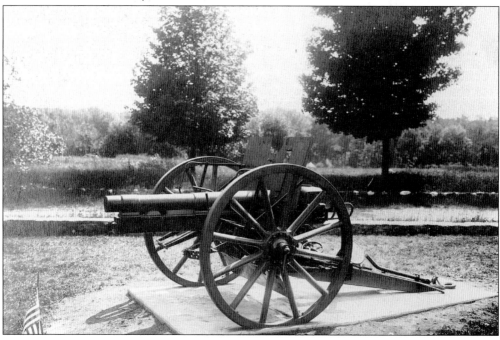

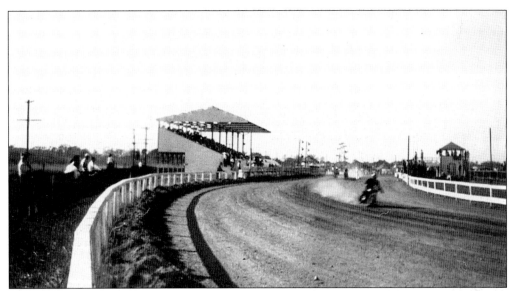

After Camp Joe Hooker was deserted, it became the site of various businesses, including the Golden Spur Ranch restaurant in the 1960s, the Middleboro Agricultural Society, and today the Lakeville Lions Club. Automobiles and motorcycles raced here from the 1930s to the 1960s. Pictured here is a motorcycle race that took place on October 5, 1946. (Courtesy Lakeville Historical Society.)

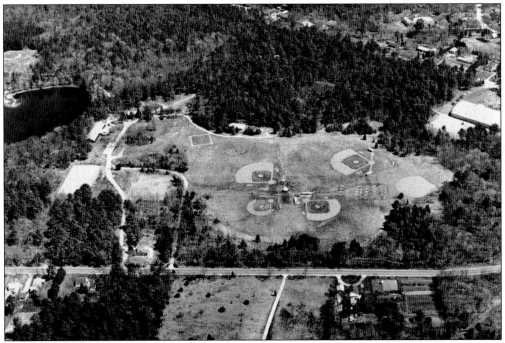

The Ted Williams Camp was a summer camp on Loon Pond with baseball as its featured activity, although there were other camp activities such as swimming and fishing. The camp was opened with Ted Williams, No. 9, of the Boston Red Sox, as a partner. It was not uncommon for Williams to make an appearance at the camp to the delight of everyone present. (Courtesy Lakeville Historical Society.)

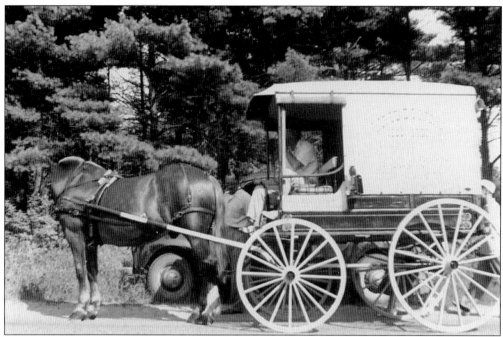

A centennial parade was held on Saturday, July 18, 1953. The parade was organized by a town committee. This float was provided by the Lakeville Animal Hospital. Dr. Ray O. Delano owned the wagon that is being driven by Winfred Perkins, his father-in-law. Also seen is Ray Delano Sr., Ray's father. (Courtesy Lakeville Historical Society.)

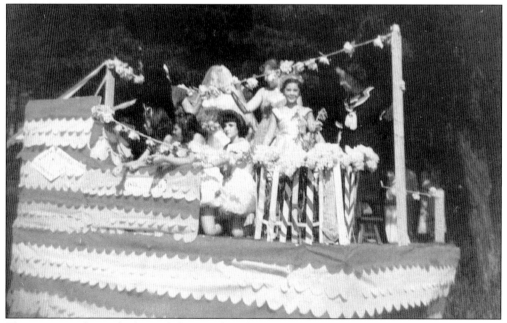

The centennial parade float of the North Lakeville Community Club featured old and new fashions. This float received second prize. Among those on the float are Mary Shaw, Rose Roberts, Helen Paska, Wendy Hamor, Wilhelmina Vinal, Jean Cabral, Doreen Paska, Dianne Roberts, Janice Hotz, and Mary Medeiros. (Courtesy Lakeville Historical Society.)

The *Assawampsett* was the second of three steamboats to cruise Lake Assawompset and the Nemasket River. The *Assawampsett* operated from 1879 until Taunton put the gate at the mouth of the river. Built by John Baylies Le Baron, the *Assawampsett* was 60 feet long and had a hinged smokestack, so it could go under the bridge. The steamboat carried 150 passengers. (Courtesy Patricia A. Stetson.)

Arthur Lawrence Atwood built this homemade tractor. It is pictured in 1941, at the home farm of Chester Peirce on Pierce Avenue. The wagon of hay was loaded in the field by hand using hay forks. The tractor was then driven into the cow barn. The hay was thrown into the loft for storage until it was needed during the winter months. (Courtesy Hubert L. and Lois Atwood.)

Cutting and milling wood were common occupations in town before the early 1900s. Men would use teams of workhorses to drag the logs out of the woods and then haul them to the local sawmills. Boxboards and shingles were among the items made in town. (Courtesy Lakeville Historical Society.)

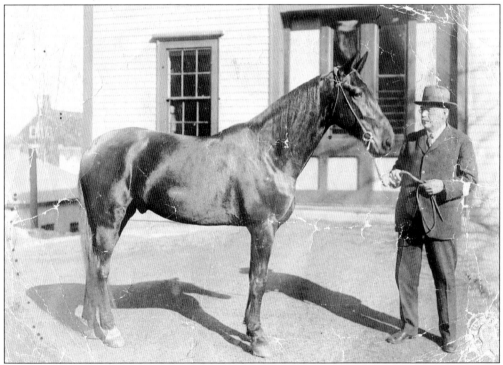

Frederick A. Shockley, one of the town's best-known citizens, and his horse Puzzle are pictured here about 1936. Shockley was a selectman and an assessor in the town for 44 consecutive years. He was first elected in 1895. In 1916, he was appointed deputy sheriff, a position he held for the rest of his life. He died in 1942. (Courtesy Lakeville Historical Society.)

Ethan Pierce, a woodcutter and teamster, lived on Pickens Street. He is pictured with a yoke of oxen at Henry Pember's house. Pember was a house builder and surveyor who lived on Main Street across from Assawompset School. Oxen were commonly used instead of horses on local farms. (Courtesy Lakeville Historical Society.)

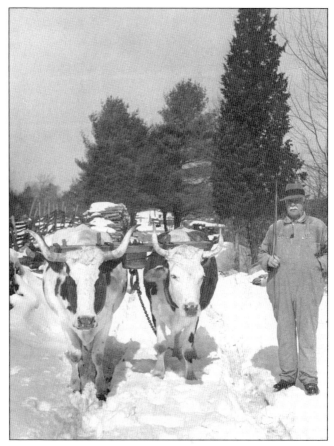

The old John Shaw house, located on Highland Road, is picture here about 1926. The first house at this site burned in 1753. The second house was torn down, and the third house was later annexed to a new dwelling. Before the 1890s, John Shaw was a keeper of the poor, providing them with room and board since Lakeville did not have a poorhouse. (Courtesy Lakeville Historical Society.)

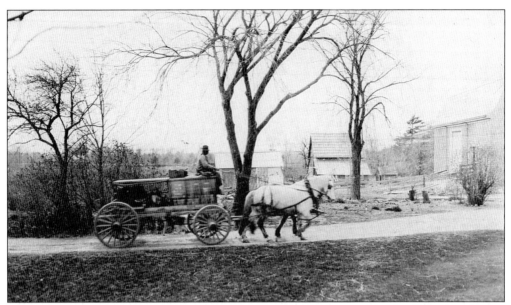

Fred Arthur Shaw, "Uncle Fred," who worked at his father's farm on Highland Road, is driving the spray wagon about 1926. The spray was used at the Shaw apple orchard. At one time, this was a 500-acre farm. A small park at the end of Highland Road was named by the town in memory of Shaw. (Courtesy Lakeville Historical Society.)

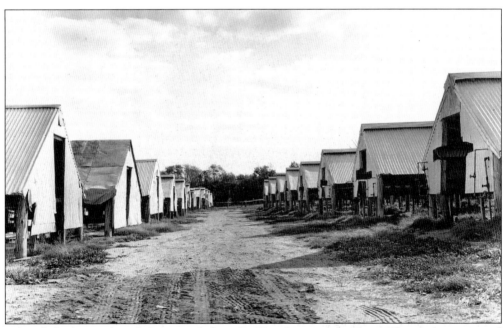

Lakeville had several mink farms, including the Hotz farm pictured here. The mink were raised to be used for making fur coats. The Hotz farm was located off Cross Street. The Hotz brothers who ran the farm came from Russia, and they were very successful at raising mink in the 1920s. (Courtesy Lakeville Historical Society.)

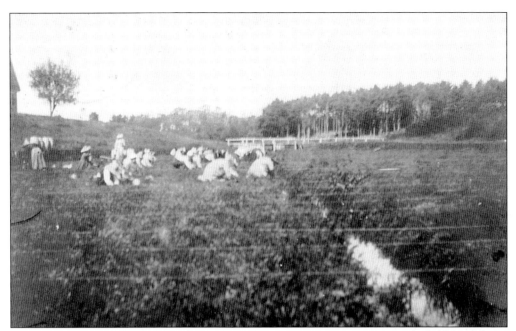

Cranberries were picked by hand at a bog off Stetson Street. Women and children did the picking while the men carried the boxes of cranberries out of the fields. There have always been many cranberry bogs in Lakeville because the low boggy land, some of which had been created when it was mined for bog iron, was perfect for growing this crop. (Courtesy Lakeville Historical Society.)

Corncribs were used to store the ears of corn after the summer harvest. The corn would be husked and left in the crib to dry on the cob so that it could be fed to the animals in the winter. Seen here running away from the crib is Richard Caswell. (Courtesy Lakeville Historical Society.)

ACROSS AMERICA, PEOPLE ARE DISCOVERING
SOMETHING WONDERFUL. *THEIR HERITAGE.*

Arcadia Publishing is the leading local history publisher in the United States. With more than 3,000 titles in print and hundreds of new titles released every year, Arcadia has extensive specialized experience chronicling the history of communities and celebrating America's hidden stories, bringing to life the people, places, and events from the past. To discover the history of other communities across the nation, please visit:

www.arcadiapublishing.com

Customized search tools allow you to find regional history books about the town where you grew up, the cities where your friends and family live, the town where your parents met, or even that retirement spot you've been dreaming about.